33 7

400

FIGURE DRAWING
Step by Step

Wendon Blake

Drawings by
Uldis Klavins

33 7

DOVER PUBLICATIONS, INC.
Mineola, New York

Copyright

Copyright © 1981 by Donald Holden
All rights reserved under Pan American and International Copyright Conventions.

Published in Canada by General Publishing Company, Ltd., 30 Lesmill Road, Don Mills, Toronto, Ontario.

Bibliographical Note

This Dover edition, first published in 1998, is a complete, unabridged republication of the work originally published in 1981 by Watson-Guptill Publications, New York, under the title *Figure Drawing: A Step-by-Step Instruction Book.*

Library of Congress Cataloging-in-Publication Data

Blake, Wendon.
 [Figure drawing]
 Figure drawing step by step / by Wendon Blake ; drawings by Uldis Klavins.
 p. cm.
 Originally published: Figure drawing. New York : Watson-Guptill Publications, 1981, in series: The artist's painting library.
 ISBN 0-486-40200-2 (pbk.)
 1. Figure drawing—Technique. I. Klavins, Uldis. II. Title.
NC765.B57 1998
743.4—dc21
 98-21530
 CIP

Manufactured in the United States of America
Dover Publications, Inc., 31 East 2nd Street, Mineola, N.Y. 11501

CONTENTS

Figure Drawing. From the time of the ancient Greeks, artists have regarded the male and female nude figure as the ultimate statement of humanity's ideals of heroism and beauty. Many great artists have devoted their entire lives to painting, sculpting, and drawing the nude figure. For the forms of the human body are endlessly fascinating. Every pose, gesture, and view presents a new challenge. Thus, artists love to draw the nude not only because the beauty of the human body is so hypnotic, but because there's always something new to learn. In fact, many teachers feel that drawing the nude is the *best* way to learn how to draw.

Proportions. Before you begin to draw the figure, it's important to establish a clear mental image of the proportions of the male and female bodies. The traditional system is to measure in head lengths. The figure drawings in this book are based on the rule that the height of the figure is roughly eight times the length of the head. Artists usually say that the figure is "eight heads tall." The legs, arms, and other sections of the body are also measured in heads. *Figure Drawing* begins by presenting this system of proportions in a series of drawings of standing male and female figures, seen from different angles.

Learning to Draw the Body. Next, you'll watch noted artist Uldis Klavins demonstrate how to draw the various parts of the body step by step. Looking at the body from various views—front, three-quarter, and side—Klavins demonstrates how to draw the male and female torso, head, arm and hand, and leg and foot.

Drawing the Total Figure. Having shown how to draw the components of the figure, Klavins then goes on to demonstrate how to assemble all this information in complete drawings of the male and female figure. You'll watch him construct all the forms of the figure from head to toe, applying the systems of proportion and the step-by-step drawing methods you've learned in earlier pages. These complete figure demonstrations, like the preceding demonstrations of the various parts of the body, show the four fundamental stages in executing a figure drawing. First Klavins shows you how to establish the major forms with simple guidelines. Then he shows you how to refine these lines to make the forms more accurate. He blocks in the broad areas of shadow. And then he completes the drawing by refining contours, strengthening the shadows, and adding details.

Step-by-Step Demonstrations. In a series of more detailed demonstrations, Klavins then shows you how to draw ten different figures step by step. He begins with simple poses, gradually introducing more complex ones. The first three demonstrations are pencil drawings of standing male and female figures, and a seated female figure. The next three demonstrations are chalk drawings: a bending male and a kneeling female figure, and a back view of a seated female figure. And the last four demonstrations are charcoal drawings of a twisting male figure, a crouching male figure, a reclining female figure, and a seated male figure. The ten demonstrations show every drawing operation in precise detail.

Drawing Media. These ten step-by-step demonstrations are executed in a variety of pencil, chalk, and charcoal techniques to reveal the full range of possibilities in these versatile media. You'll see how to build contour, form, and light and shade with various combinations of lines, strokes, and blended tones. And the drawings are executed on a variety of papers to show you the effects of varied drawing surfaces.

Finding Models. As most artists and art students have discovered, people aren't nearly as shy as they used to be. Members of your family, friends, and acquaintances are accustomed to today's revealing beachwear and resort fashions, and so they're often flattered by an invitation to pose. If you prefer to draw a professional model, check your nearest art school, college, or university to see whether they've got a so-called life class which you can join. Sometimes a life-drawing class includes the services of an instructor, but it's also common for a school to hire a professional model and simply provide a studio in which a group of students or serious amateurs can draw for several hours, merely paying a modest admission fee. You can also form your own life class with friends, working in someone's home and sharing the cost of the model's fee. To find a professional model for your own life class, you might call your local art school, college, or university to find out where they get their models. Professional artists often contact dance or drama schools whose students are willing to model to finance their professional training. The important thing is to work from the living figure—not from photographs—and to draw as often as you can. If you join a life class—or form your own—be sure to go at least once a week. When you go to the beach or to the swimming pool, take your sketch pad. Ask permission to make drawings at dance classes and the local gym. If there's a museum nearby whose collection includes Greek or Roman sculpture, you're especially lucky: you can draw beautifully proportioned models who never get tired and never move!

Keep It Simple. The best way to start drawing is to get yourself just two things: a pencil and a pad of white drawing paper about twice the size of the page you're now reading. An ordinary office pencil will do—but test it to make sure that you can make a pale gray line by gliding it lightly over the paper, and a rich black line by pressing a bit harder. If you'd like to buy something at the art-supply store, ask for an HB pencil, which is a good all-purpose drawing tool, plus a thicker, darker pencil for bolder work, usually marked 4B, 5B, or 6B. Your drawing pad should contain sturdy white paper with a very slight texture—not as smooth as typing paper. (Ask for cartridge paper in Britain.) To get started with chalk drawing, all you need is a black pastel pencil or a Conté pencil. And just two charcoal pencils will give you a good taste of charcoal drawing: get one marked "medium" and another marked "soft." You can use all these different types of pencils on the same drawing pad.

Pencils. When we talk about pencil drawing, we usually mean *graphite* pencil. This is usually a cylindrical stick of black, slightly slippery graphite surrounded by a thicker cylinder of wood. Artists' pencils are divided roughly into two groupings: soft and hard. A soft pencil will make a darker line than a hard pencil. Soft pencils are usually marked B, plus a number to indicate the degree of softness—3B is softer and blacker than 2B. Hard pencils are marked H and the numbers work the same way—3H is harder and makes a paler line than 2H. HB is considered an all-purpose pencil because it falls midway between hard and soft. Most artists use more soft pencils than hard pencils. When you're ready to experiment with a variety of pencils, buy a full range of soft ones from HB to 6B. You can also buy cylindrical graphite sticks in various thicknesses to fit into metal or plastic holders. And if you'd like to work with broad strokes, you can get rectangular graphite sticks about as long as your index finger.

Chalk. A black pastel pencil or Conté pencil is just a cylindrical stick of black chalk and, like the graphite pencil, it's surrounded by a cylinder of wood. But once you've tried chalk in pencil form, you should also get a rectangular black stick of hard pastel or Conté crayon. You may also want to buy cylindrical sticks of black chalk that fit into metal or plastic holders.

Charcoal. Charcoal pencils usually come in two forms. One form is a thin stick of charcoal surrounded by wood, like a graphite pencil. Another form is a stick of charcoal surrounded by a cylinder of paper that you can peel off in a narrow strip to expose fresh charcoal as the point wears down. When you want a complete "pal-ette" of charcoal pencils, get just three of them, marked "hard," "medium," and "soft." (Some manufacturers grade charcoal pencils HB through 6B, like graphite pencils; HB is the hardest and 6B is the softest.) You should also buy a few sticks of natural charcoal. You can get charcoal "leads" to fit into metal or plastic holders like those used for graphite and chalk.

Paper. You could easily spend your life doing wonderful drawings on ordinary white drawing paper, but you should try other kinds. Charcoal paper has a delicate, ribbed texture and a very hard surface that makes your stroke look rough and allows you to blend your strokes to create velvety tones. And you should try some *really* rough paper with a ragged, irregular "tooth" that makes your strokes look bold and granular. Ask your art-supply dealer to show you his roughest drawing papers. Buy a few sheets and try them out.

Erasers (Rubbers). For pencil drawing, the usual eraser is soft rubber, generally pink or white, which you can buy in a rectangular shape about the size of your thumb or in the form of a pencil, surrounded by a peel-off paper cylinder like a charcoal pencil. For chalk and charcoal drawing, the best eraser is kneaded rubber (or putty rubber), a gray square of very soft rubber that you can squeeze like clay to make any shape that's convenient. A thick, blocky soap eraser is useful for cleaning up the white areas of the drawing.

Odds and Ends. You also need a wooden drawing board to support your drawing pad—or perhaps a sheet of soft fiberboard to which you can tack loose sheets of paper. Get some single-edge razor blades or a sharp knife (preferably with a safe, retractable blade) for sharpening your drawing tools; a sandpaper pad (like a little book of sandpaper) for shaping your drawing tools; some pushpins or thumbtacks (drawing pins in Britain); a paper cylinder (as thick as your thumb) called a stomp, for blending tones; and a spray can of fixative, which is a very thin, virtually invisible varnish to keep your drawings from smudging.

Work Area. When you sit down to work, make sure that the light comes from your left if you're right-handed, and from your right if you're left-handed, so your hand won't cast a shadow on your drawing paper. A jar is a good place to store pencils, sharpened end up to protect the points. Store sticks of chalk or charcoal in a shallow box or in a plastic silverware tray with convenient compartments—which can be good for storing pencils too. To keep your erasers clean, store them apart from your drawing tools—in a separate little box or in a compartment of that plastic tray.

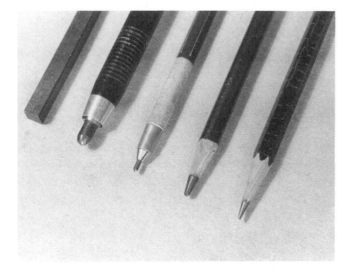

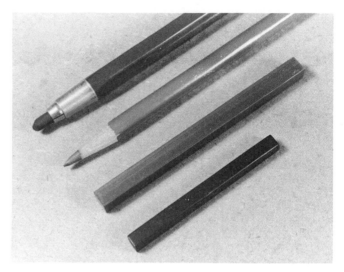

Pencils. The common graphite pencil comes in many forms. Looking from right to left, you see the all-purpose HB pencil; a thicker, softer pencil that makes a broader, blacker mark; a metal holder that grips a slender, cylindrical lead; a plastic holder that grips a thick lead; and finally a rectangular stick of graphite that makes a broad, bold mark on the paper. It's worthwhile to buy some pencils as well as two or three different types of holders to see which ones feel most comfortable in your hand.

Chalk. Shown here are four kinds of chalk. Looking from the lower right to the upper left, you see the small, rectangular Conté crayon; a larger, rectangular stick of hard pastel; hard pastel in the form of a pencil that's convenient for linear drawing; and a cylindrical stick of chalk in a metal holder. All these drawing tools are relatively inexpensive, so it's a good idea to try each one to see which one you like best.

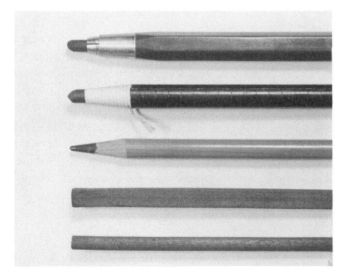

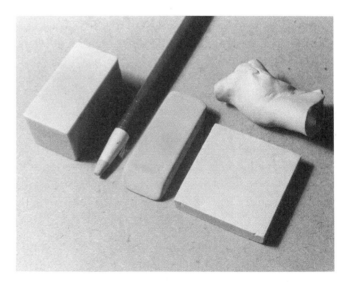

Charcoal. This versatile drawing medium comes in many forms. Looking up from the bottom of this photo, you see a cylindrical stick of natural charcoal; a rectangular stick of natural charcoal; a charcoal pencil; another kind of charcoal pencil—with paper which you gradually tear away as you wear down the point; and a cylindrical stick of charcoal in a metal holder. Natural charcoal smudges and erases easily, so it's good for broad tonal effects. A charcoal pencil makes firm lines and strokes, but the strokes don't blend as easily.

Erasers (Rubbers). From left to right, you see the common soap eraser, best for cleaning broad areas of bare paper; a harder, pink eraser in pencil form for making precise corrections in small areas of graphite-pencil drawings; a bigger pink eraser with wedge-shaped ends for making broader corrections; and a square of kneaded rubber (putty rubber) that's best for chalk and charcoal drawing. Kneaded rubber squashes like clay (as you see in the upper right) and can take any shape you want. Press the kneaded rubber down on the paper and pull away; scrub only when necessary.

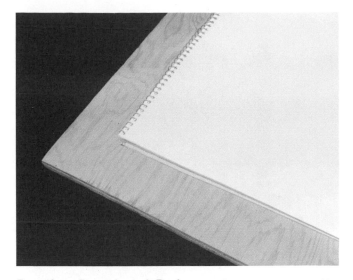

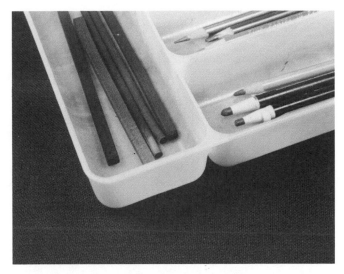

Drawing Board and Pad. Drawing paper generally comes in pads that are bound on one edge like a book. Most convenient is the spiral binding like the one you see here, since each page folds behind the others when you've finished a drawing. The pad won't be stiff enough to give you proper support by itself, so get a wooden drawing board from your art supply store—or simply buy a piece of plywood or fiberboard. If you buy your drawing paper in sheets, rather than pads, buy a piece of soft fiberboard to which you can tack your paper.

Storage. Store your pencils, sticks of chalk, and sticks of charcoal with care—don't just toss them into a drawer where they'll rattle around and break. The compartments of a silverware container (usually made of plastic) provide good protection and allow you to organize your drawing tools into groups. Or you can simply collect long, shallow cardboard boxes—the kind that small gifts often come in.

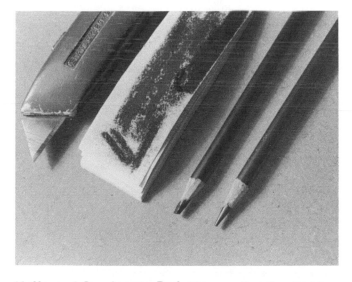

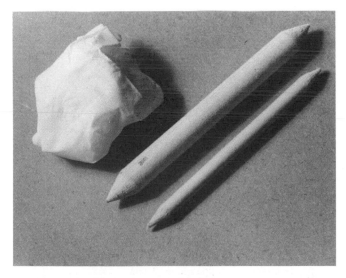

Knife and Sandpaper Pad. The pencil at the right has been shaped to a point with a mechanical pencil sharpener. The other pencil has been shaped to a broader point with a knife and sandpaper. The knife is used to cut away the wood without cutting away much of the lead. Then the pencil point is rubbed on the sandpaper to create a broad, flat tip. Buy a knife with a retractable blade that's safe to carry. To the right of the knife is a sandpaper pad that you can buy in most art-supply stores; it's like a small book, bound at one end so you can tear off the graphite-coated pages.

Stomps and Cleansing Tissue. To blend pencil, chalk, or charcoal, you can buy stomps of various sizes in any good art-supply store. A stomp is made of tightly rolled paper with a tapered end and a sharp point. Use the tapered part for blending broad areas and the tip for blending small areas. A crumpled cleansing tissue can be used to spread a soft tone over a large area. Natural charcoal is so soft that you can dust off an unsatisfactory area with the tissue.

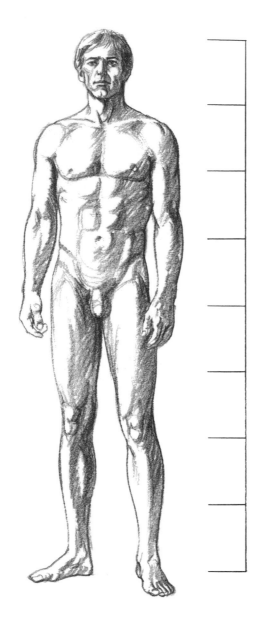

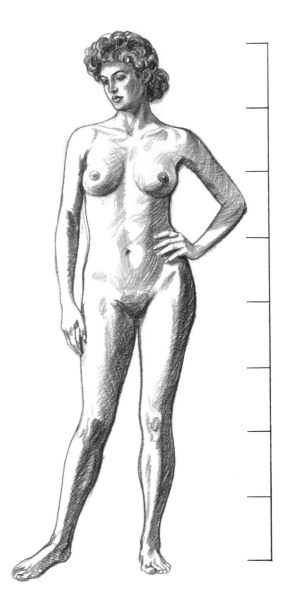

Male Figure. Although no two models are exactly alike, it's helpful to memorize the proportions of an "ideal" figure and keep these proportions in mind as you draw. Most artists use the head as the unit of measurement. They generally visualize a figure that's eight heads tall. The torso is about three heads tall from the chin to the crotch, divided into thirds at the nipple line and navel. The upper leg is two heads tall, and so is the lower leg. At its widest point, the shoulders, the ideal male figure measures just over two head lengths.

Female Figure. The ideal female figure is also about eight heads tall, though you can see that she's just a bit shorter than the ideal male figure at your left. At its two widest points, the shoulders and hips, she measures about two head lengths. In both these figures, notice that the elbows are approximately three head lengths down from the top of the head and align with the narrowest point of the waist, while the wrists align with the crotch. Naturally, these alignments change when the model bends her arm.

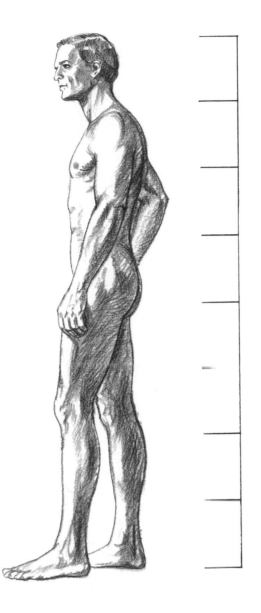

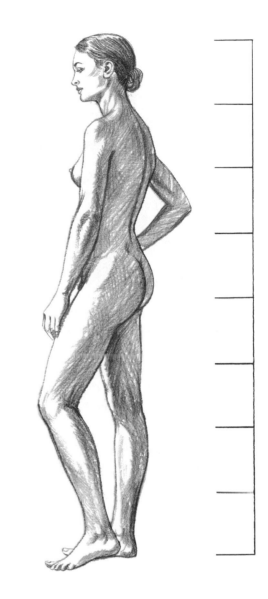

Male Figure. The proportions are essentially the same when you see the figure from the side. Note that the lower edge of the chest muscle comes about halfway down the upper arm. The lower edge of the buttocks is slightly more than four heads down from the top of the figure—a bit farther down than the crotch. As the model bends his arms, the elbows no longer align with the waist but rise farther up. Seen from the side, the foot measures slightly more than one head length.

Female Figure. In profile, the female figure has the same proportions as the male figure, although she's slightly smaller. Once again, you can see that the breast comes about halfway down the upper arm, and the lower edge of the buttocks is just below the midpoint of the figure. From the shoulder to the wrist, the arm length is slightly under three heads, which means that the upper and lower arms should each measure roughly one and one-half heads. As in the male figure, the female foot is just over one head long. The outstretched hand is slightly less than one head long.

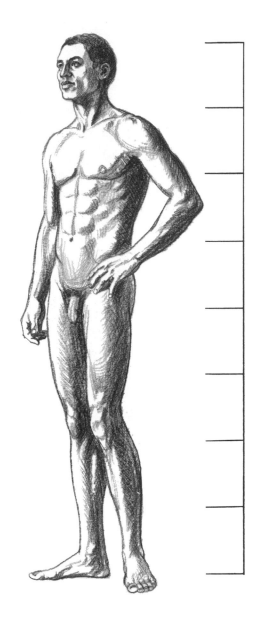

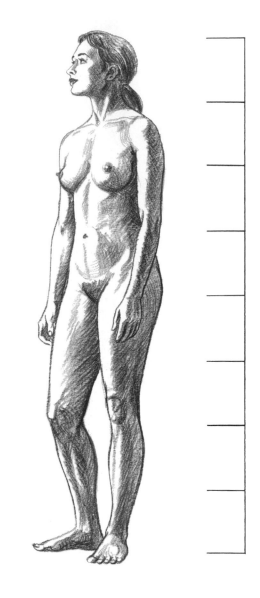

Male Figure. When the male figure turns to a three-quarter view, the vertical proportions remain the same, but the horizontal proportions change. The shoulders are less than two heads wide, and the entire torso has narrowed slightly. Study the proportions of the bent arm: the upper and lower arms are each approximately one and one-half heads long, while the hand is just under one head long. As the arm bends, the elbow rises above the midpoint of the figure, and the wrist no longer aligns with the crotch. When one leg bends and the other remains straight, the knee of the bent leg tends to drop slightly.

Female Figure. Here you can see clearly how the knee drops slightly as the leg bends. In the three-quarter view, the shoulders and hips are no longer two heads wide, but have become narrower. (As the model keeps turning toward the side view, those widths become narrower still.) The lower edge of the breast comes about halfway down the upper arm. The elbows align more or less with the navel, although the female navel is usually slightly lower than that of the male. The lower edge of the knee is two heads up from the heel.

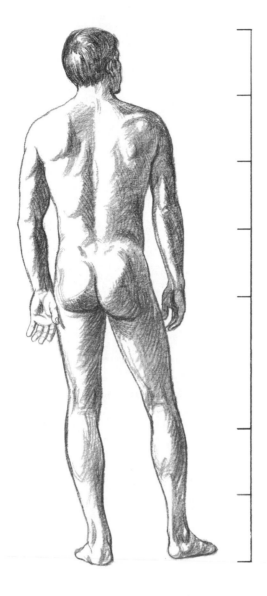

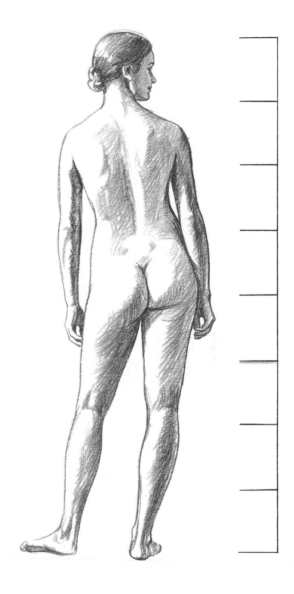

Male Figure. Seen from behind, the figure displays the same proportions as in the front view—with some subtle differences. The lower edges of the buttocks fall slightly below the midpoint of the figure—unlike the crotch, which is usually just four heads down from the top of the head. The horizontal creases at the backs of the knees, dividing the upper and lower legs, are slightly more than two heads up from the heel—in contrast with the lower edges of the front of the knees, which are a bit farther down. Note that the lower edges of the shoulder blades are two heads down from the top of the figure, which means one head down from the neck. The shoulders measure a shade over two head lengths, while the hips measure about one and one-half.

Female Figure. In this view, you can see one of the major differences between the male and female figures. In the male figure at your left, the shoulders are distinctly wider than the hips, while the female figure is equally wide at both points—roughly two head lengths. Once again, you can see that the crease that divides the upper and lower legs in back is distinctly higher than the lower edge of the knee that you see in the front view. Obviously, not every model will have the ideal proportions you see in these drawings. But if you stay reasonably close to these measurements, making some adaptations to suit each model, your figure proportions will always be convincing.

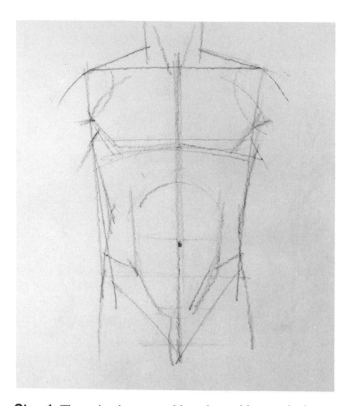

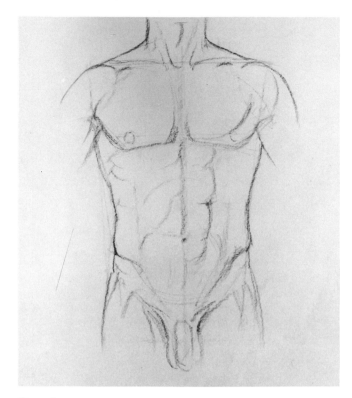

Step 1. The artist draws an oblong box with a vertical center line. Horizontal guidelines locate the shoulders, nipples, navel, crotch, and abdominal muscles. He begins to suggest anatomical shapes.

Step 2. The artist draws the anatomical shapes with more realistic, curving lines. He rounds off square chest muscles and traces the curves of the rib cage, waist, and thighs.

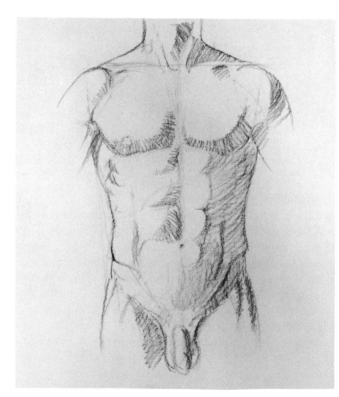

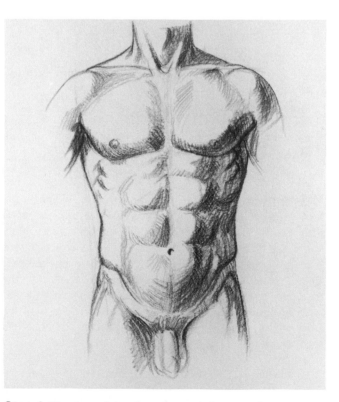

Step 3. He blocks in the tonal areas with the side of the pencil lead. The light comes from the left and from slightly above, so the right sides of the forms are in shadow—and so are the undersides.

Step 4. He strengthens the tones and sharpens the contours. You now see four distinct tones: light; halftone (between the lights and shadows); shadow; and reflected light (paler tones within the shadows).

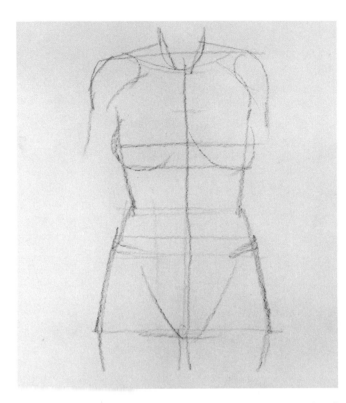

Step 1. The artist visualizes the female torso as a pair of blocky shapes that taper inward to the waist. A vertical center line and horizontal guidelines locate the shoulders, nipples, breasts, navel, and crotch.

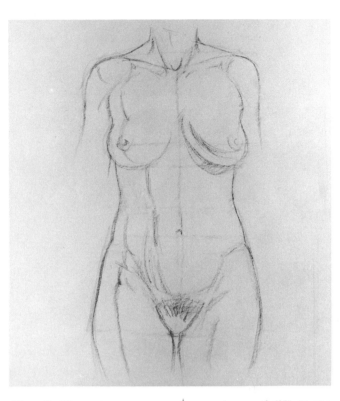

Step 2. The artist constructs the curving contours of the figure over the geometric guidelines of Step 1. Within the shapes of the breasts, abdomen, and hips, he suggests the edge of the shadow area.

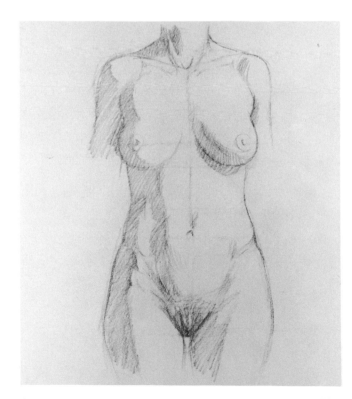

Step 3. He blocks in the shadows with parallel strokes. The light comes from the right, so the left sides of the forms are in shadow. On the lighted side of the body, the breast casts a circular shadow.

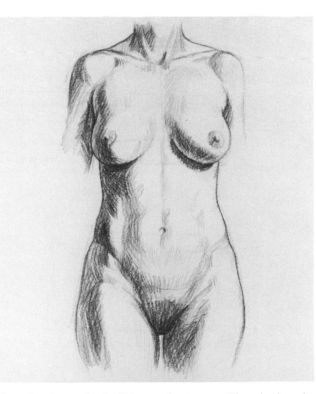

Step 4. The artist builds up the tones. The shadow is darkest where light and shadow areas meet—turning paler as it begins to pick up reflected light from a distant source. You can see this on the breast.

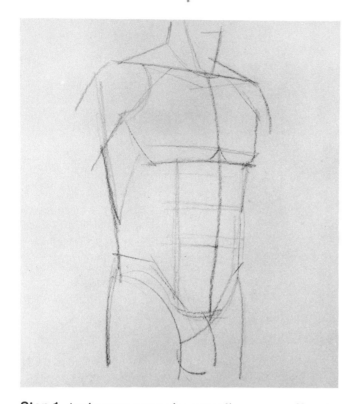

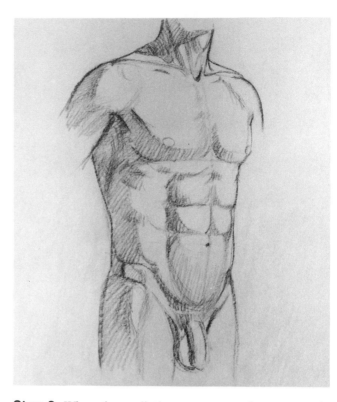

Step 1. As the torso turns, the center line moves off center and the boxy shape of the figure becomes narrower than in the front view. The artist works with the usual guidelines to construct the basic "diagram."

Step 2. When the realistic contours are drawn over the guidelines, the alignments remain the same. The pit of the neck, the division between the chest and stomach muscles, the navel, and the crotch are all on the same vertical line.

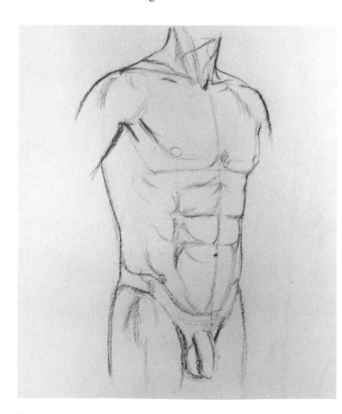

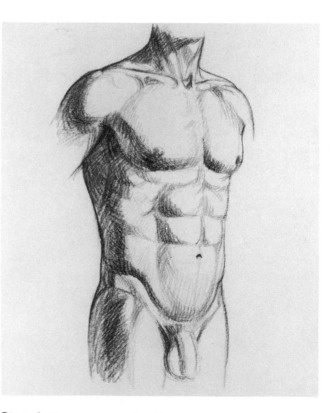

Step 3. The light comes from the right and from slightly above, so the shadow planes are on the left sides and along the undersides of the forms. The artist blocks in the shadow shapes with clusters of parallel strokes, as usual.

Step 4. By now, you should be able to identify the four basic tones in the finished drawing. The light, halftone (or middle tone), shadow, and reflected light are apparent on the chest muscle and thigh.

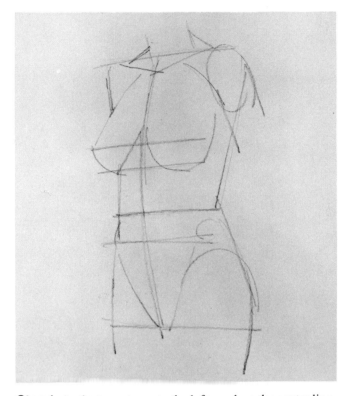

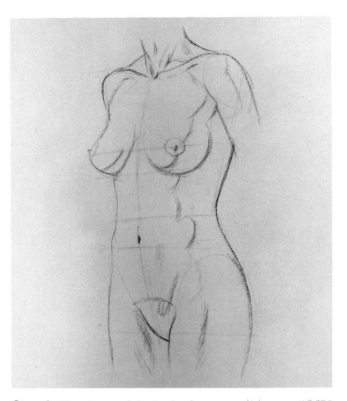

Step 1. As the torso turns to the left, so does the center line. The upper and lower halves taper toward the waist. The artist places the usual horizontal guidelines and visualizes the shoulder as an egg shape.

Step 2. The shape of the body changes as it turns, and the center line curves slightly, but the most important alignments remain the same in the realistic line drawing. For example, the shoulders still align with the hips.

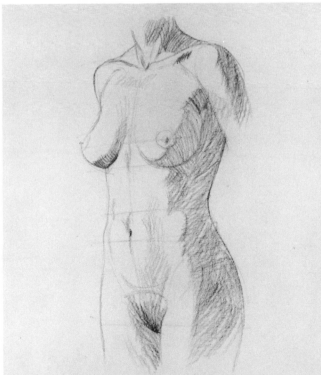

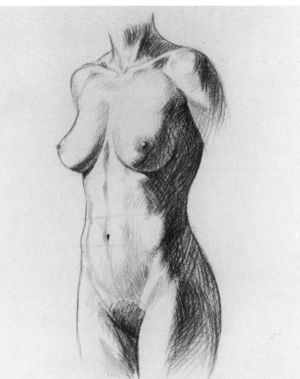

Step 3. The light source is at the left, so the artist blocks in the big shadow zones on the right sides of the forms. He places a delicate halftone where the abdomen curves away from the light.

Step 4. As the artist builds up the tones, stroke over stroke, he plans the direction of the strokes to follow the forms and accentuate their roundness. He applies less pressure to the pencil in the halftone areas.

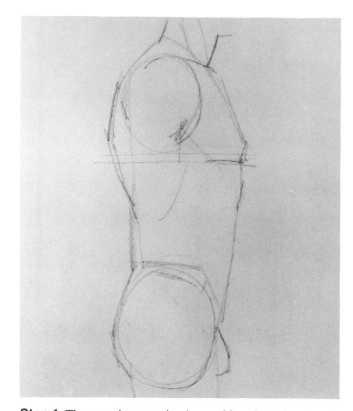

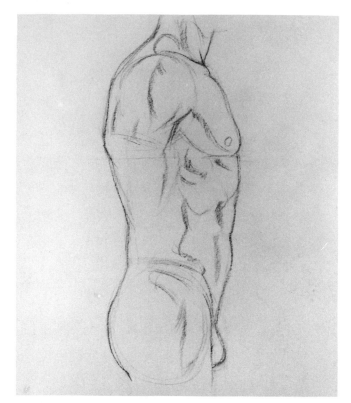

Step 1. The torso is a tapering box, with a slanted rectangle for the chest muscle and egg shapes for the shoulder and hip. The back curves out at the shoulder, in at the waist, and then out again at the buttocks.

Step 2. The blocky shapes of the "diagram" are rounded off in the realistic line drawing. The neck normally leans forward, the upper torso leans backward, and the lower torso leans slightly forward again to meet the upper torso.

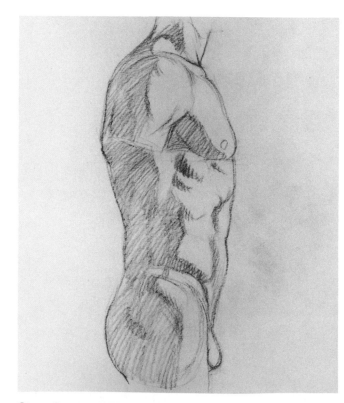

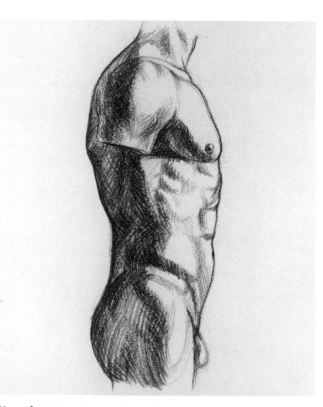

Step 3. The light comes from the right, placing the left sides of the forms in shadow, which the artist blocks in with parallel strokes. Study the alignments: the point of the shoulder is directly above the center of the hip.

Step 4. When the artist builds up the tones—accentuating the contours with the pencil point—you can see the gradation of light, halftone, shadow, and reflected light most clearly on the chest muscle, shoulder, and hip.

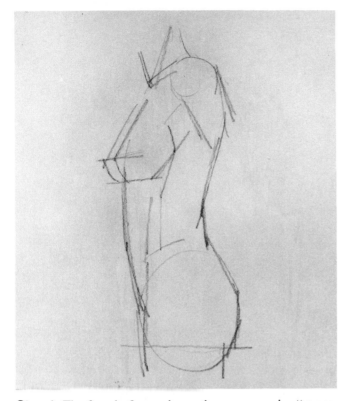

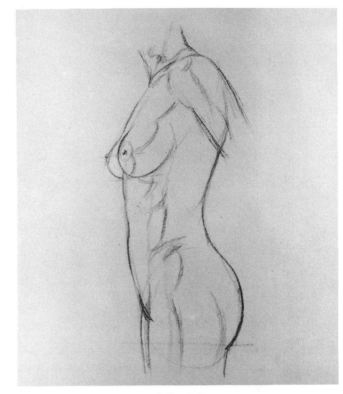

Step 1. The female figure shows the same angular "movement" as that of the male. The neck tilts forward, the upper torso leans back, and the lower torso tilts forward to meet the upper torso at the waist.

Step 2. The pencil point defines the edges of the forms and the contours of the shadows within the forms. The female buttocks protrude more than those of the male, but the center of the shoulder still aligns with the center of the hip.

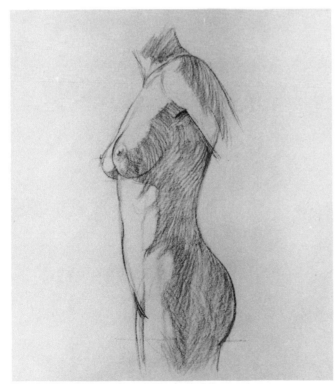

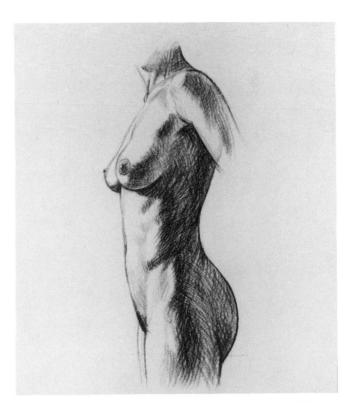

Step 3. The light source is at the left, illuminating the front of the figure and placing the back—as well as much of the side—in shadow. The artist follows the shadow guidelines of Step 2 as he blocks in the tones.

Step 4. The finished torso shows the gradation of light, halftone, shadow, and reflected light, plus the cast shadow beneath the breast. Within the lighted abdomen, halftones suggest anatomical detail.

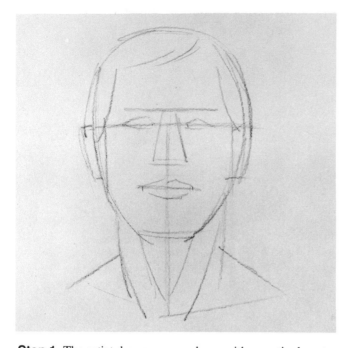

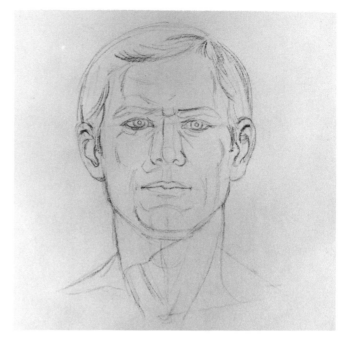

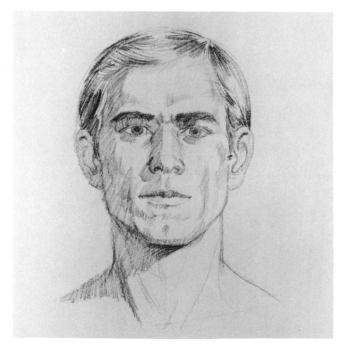

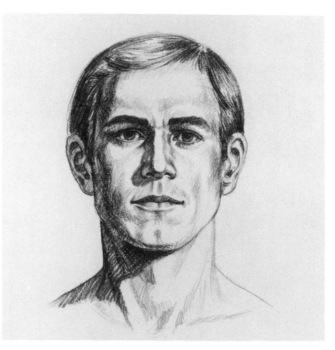

Step 1. The artist draws an egg shape with a vertical center line. Horizontal lines locate the features: the eyes are halfway down; the underside of the nose is midway between eyes and chin; the division between the lips is one-third down from nose to chin. Over these guidelines, he places the features, squares up the jaw, and indicates the hair.

Step 2. Study the proportions of the realistic head, drawn over the guidelines of Step 1. The height of the head, from chin to crown, is one and one-half times the width from cheek to cheek. At its midpoint, the head is "five eyes wide." The space between the eyes, and the underside of the nose, are both "one eye wide." The ears align with the eyes (or eyebrows) and mouth.

Step 3. The artist blocks in the shadows, following the guidelines you saw in Step 2. The light comes from the right, and so the shadow is on the left side of the head. The eye sockets and upper lip curve away from the light, and so they contain deep shadows. The corner of the nose casts a slanted shadow to the left; the chin casts a shadow across the neck in the same direction.

Step 4. The shadows on the left sides of the forms are darkened. So are the undersides of the forms that curve inward, away from the light: the eye sockets, bottom of the nose, upper lip, underside of the lower lip, and chin. The artist strengthens the halftones in the lighted areas, defines the details of the features, and reinforces the outer contours.

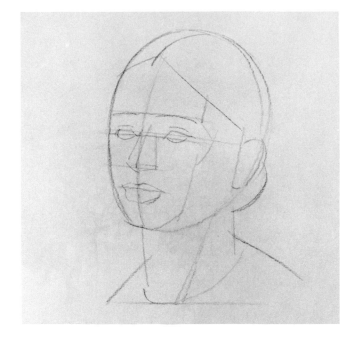

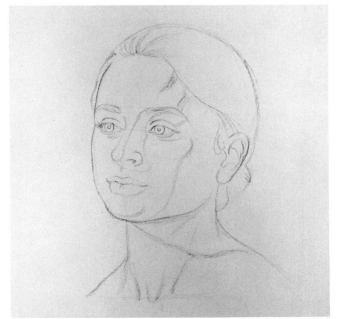

Step 1. The head is turned slightly to the left in this three-quarter view. Again, the artist draws an egg shape with a vertical center line—which moves to the left as the head turns—plus horizontal lines to locate the features. Then the features go over these guidelines. The artist indicates the shape of the shadow that runs down the forehead, cheek, and jaw.

Step 2. Over the egg, the artist traces the curves of the forehead, cheek, jaw, and chin; defines the eyebrows and eyelids, adding the irises and pupils; indicates the tip of the nose and the nostril wing as separate, rounded shapes. He draws the wing shapes of the upper lip; the fuller, lower lip; and the internal detail of the ear.

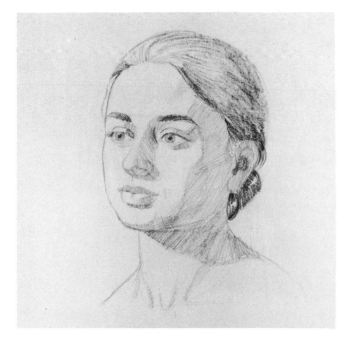

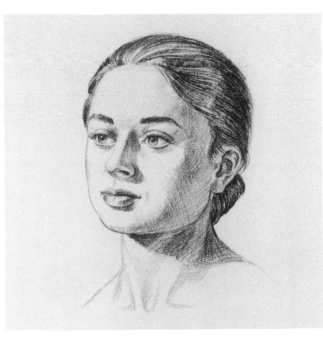

Step 3. The light comes from the left, and so the artist blocks in the big shadow that runs down the right side of the head, including the ear. He places shadows in the corners of the eye sockets; on one side of the nose and beneath it; on the upper lip, which tilts away from the light; beneath the lower lip; and at the tip of the chin. Finally, he darkens the hair.

Step 4. The artist reinforces the shadow shapes, faithfully following the shadow edge that first appeared in Step 1. With clusters of curving strokes, he darkens the big shadow shape on the side of the head and then intensifies the shadows on the features. The pencil point completes the hair, adds the details of the features, and reinforces the contours.

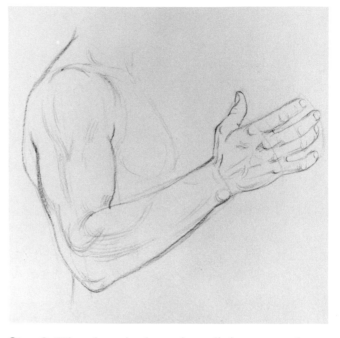

Step 1. The artist visualizes the upper and lower arms as cylinders. He draws a center line through the upper arm to align the elbow and the center of the shoulder—which he defines as a sphere. The back of the hand is drawn as a square from which the thumb projects. Straight lines define the fingers. Parallel guidelines align the knuckles.

Step 2. When the artist draws the realistic contours, he retains the spherical form of the shoulder muscle and the tapering shape of the lower arm, adding the curves of the other muscles. As he draws the hand, he follows the curving guidelines of the knuckles. The thumb is only half the length of the hand; the tip of the thumb stops where the fingers begin.

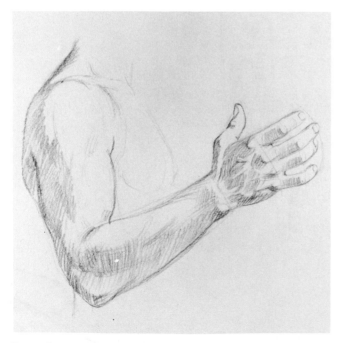

Step 3. Blocking in the shadows, the artist follows the curves of the spherical shoulder muscle, the rounded back of the upper arm, and the tapered cylinder of the forearm. In this view, the back of the hand and the first joints of the fingers bend away from the light, so they're in shadow. The light strikes the protruding knuckles, plus the second and third joints.

Step 4. The artist renders the shadow as a continuous, flowing shape that follows the curves of the muscles down to the protruding knob of the wrist, which catches the light. He accentuates the shadows on the back of the hand and behind the knuckles. The pencil point reinforces the contours of the arm and hand, and then sharpens the details of the knuckles and fingernails.

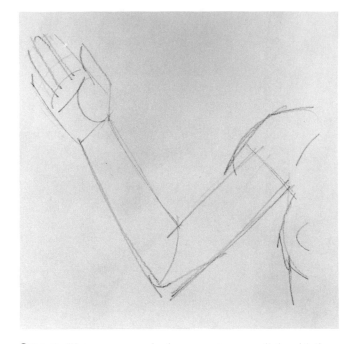

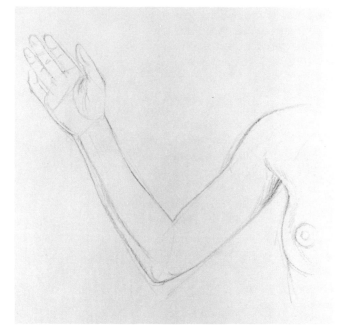

Step 1. The upper arm is drawn as two parallel guidelines with a curve for the shoulder. The lines of the forearm taper to the wrist. The palm is a boxlike shape; a curve defines the bulge of the muscle that connects to the thumb. Parallel lines locate the fingers. The palm and fingers are crossed by curving lines that locate the creases behind the knuckles.

Step 2. The shoulder and upper arm flow together in a single curving line. The shoulder muscle overlaps the upper arm and flows into the breast. The forearm isn't exactly straight, but bends slightly as it approaches the wrist. The curves of the fingers follow the guidelines of Step 1, as do the creases that cross the hand. The length of the thumb is roughly equivalent to the palm.

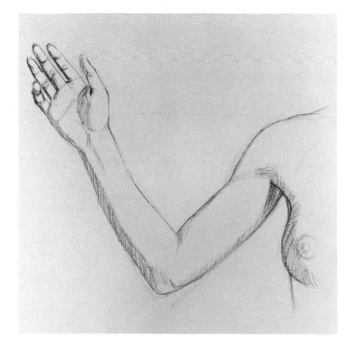

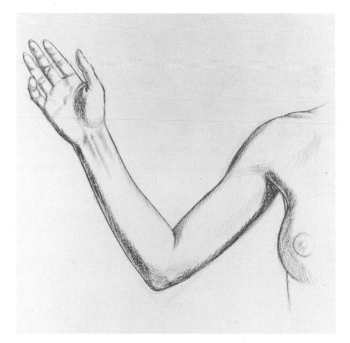

Step 3. A slender shadow runs along the underside of the arm, continuing along the edge of the hand. The shadowy edge of the chest muscle flows into the breast. A strong shadow emphasizes the roundness of the big muscle that connects to the thumb. The fingers begin to look cylindrical as the artist adds hints of shadow to their edges.

Step 4. The artist darkens the shadowy edges and then adds subtle halftones in the lighted areas to suggest additional detail such as the inner edges of the shoulder muscle and the slender cords of the wrist. The fingers become rounder as he intensifies the shadows. The pencil point reinforces the creases in the palm, the insides of the knuckles, and the fingernails.

Step 1. The preliminary line drawing visualizes the upper and lower legs as cylinders that taper toward the knees and ankles. In this pose, one knee is slightly lower than the other; the artist draws a sloping line between the knees to establish this relationship. As seen from the side, the foot is a triangle with a blocky heel and a circular knob for the protruding anklebone. The other foot, seen from the front, is a short, blocky wedge. Notice how the artist adds vertical center lines to both thighs and to one lower leg, just as he does when he draws the head or torso.

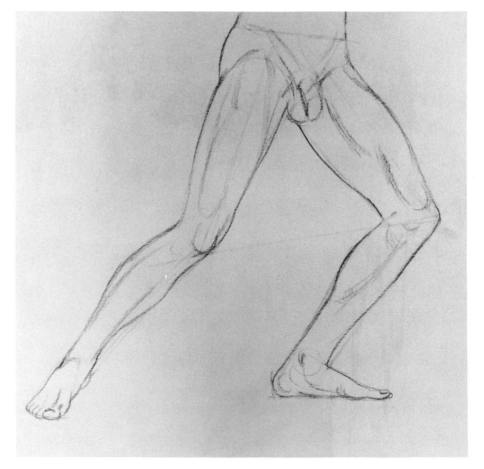

Step 2. The realistic line drawing emphasizes the muscular bulges of the thighs and the characteristic curves of the lower legs. The bulging muscles of the inner thigh and inner calf are particularly important in making a lifelike drawing of the leg. In drawing the feet, the artist rounds off the heels as separate shapes and emphasizes the bulge behind the big toe. Notice how the toes of the foot at the left all come down to the curving guideline that defined the end of the foot in Step 1.

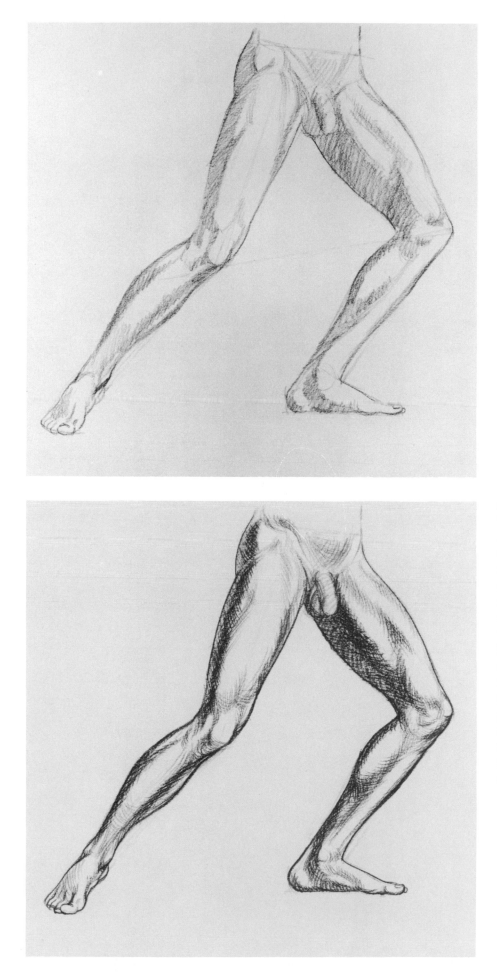

Step 3. The light comes from the upper right, and so the left sides of the forms are in shadow. The artist blocks in the big shadow planes of the thighs and the slimmer ones of the lower legs with broad parallel strokes, using the side of the lead. The bending leg on the right also has slender troughs of shadow within the thigh and calf; the artist emphasizes these to make the masses of muscle round and three-dimensional. In the knee on the left, notice how the top plane receives the light, while the underside turns away into shadow.

Step 4. In the final step, the artist builds up not only the shadows along the edges of the forms, but also the strips of shadow *within* the upper and lower legs, thus emphasizing the individual muscle masses. Notice the egglike shapes of the muscles above the knees, as well as the prominent muscle behind the calf. On the leg on the left, a slender strip of shadow runs from the knee to the inner ankle, dramatizing the curve of the muscle that protrudes from the inner edge of the calf. The sharp point of the pencil restates all the contours and emphasizes such details as the toes and the small bones of the ankle.

Step 1. When the legs bend more sharply, the forms of the knees are more rounded; the artist emphasizes their spherical forms in this preliminary line drawing. Once again, he represents the upper and lower legs as cylinders that taper inward toward the knees and ankles. Even at this stage, the female legs look less angular and more rounded than the male legs in the preceding demonstration. Seen from the side, one foot is essentially triangular—with a slight dip in the arch—while the foot that's seen from the front view is a tapering wedge with a rounded guideline to show the alignment of the tips of the toes.

Step 2. The roundness of the knees becomes even more obvious in the realistic line drawing. The curves of the female legs are more subtle than the more muscular contours of the male legs. The front and back of each thigh are single curving lines, while the lower legs are drawn as compound S-curves. The foot in profile is faithful to the original triangular shape. The toes of the other foot carefully follow the curving guideline of Step 1. Notice how the calf muscle swells in the leg that's more sharply bent.

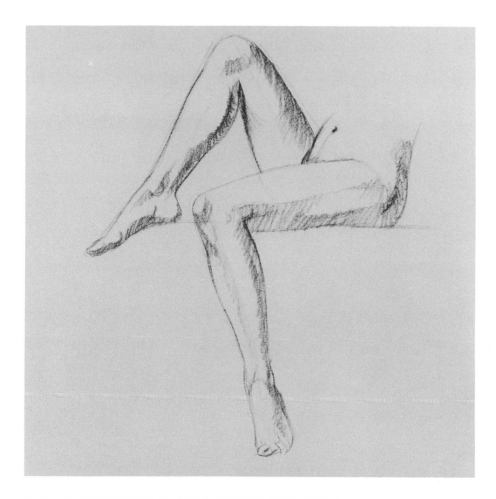

Step 3. The light comes from the left and from slightly above, and so the right sides of the forms—and the undersides—are in shadow. The artist blocks in the shadow edges of the upper and lower legs. He models curving shadows around the knees, emphasizing the rounded shapes. A delicate shadow moves down the sharp edge of the bone that runs from the knee to the ankle of the leg in the lower half of the picture. A curving shadow emphasizes the shape of the buttock. Small, curving shadows also accentuate the roundness of the heel and the bulge behind the toe of the foot that's seen in profile.

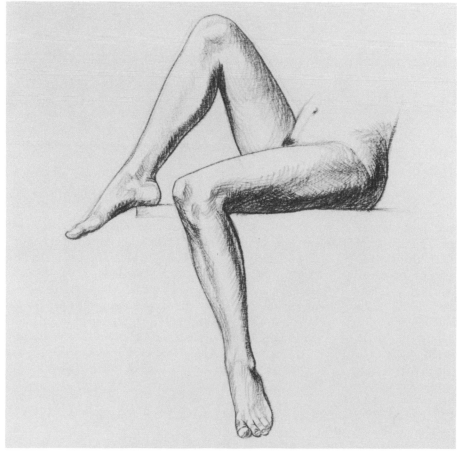

Step 4. In the final step, the artist darkens the strong shadows along the right sides and undersides of the upper and lower legs. He then adds pale strips of halftone to suggest the divisions between the groups of muscles within the lower legs. The curving pencil strokes express the roundness of forms. The four major tones—light, halftone, shadow, and reflected light—are all clearly defined and give the leg a feeling of solidity.

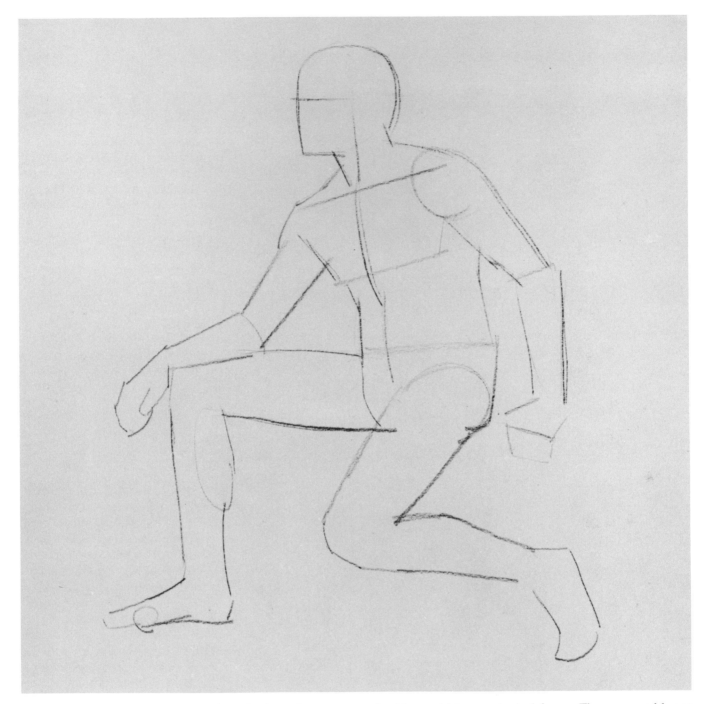

Step 1. So far, you've seen how to draw the figure in parts; now the artist puts together everything you've learned and demonstrates how to draw a complete male figure. The preliminary line drawing combines the same sort of simple shapes and guidelines you've studied in the preceding pages. The head is essentially an egg shape, squared up at the chin. The neck is a tilted cylinder, represented by two parallel lines, plus a third line to indicate the neck muscle. The torso is a tapered, boxlike shape divided by a vertical center line, plus horizontal guidelines at the shoulders, nipples, and navel. Two slanted lines connect the neck to the shoulders, which are spherical forms. The upper and lower arms are tapering cylinders. The hand on the right consists of two square shapes, one for the back of the hand and the other for the group of fingers. The hand on the left is an adaptation of that shape; again the fingers are visualized as a single mass with a curving line to indicate the tips. The upper and lower legs (like the arms) are tapering cylinders with a bulge behind the calf and a rounded shape at the bent knee. The feet are tapered wedges; the bent toes of the foot on the right are indicated as a single curving shape.

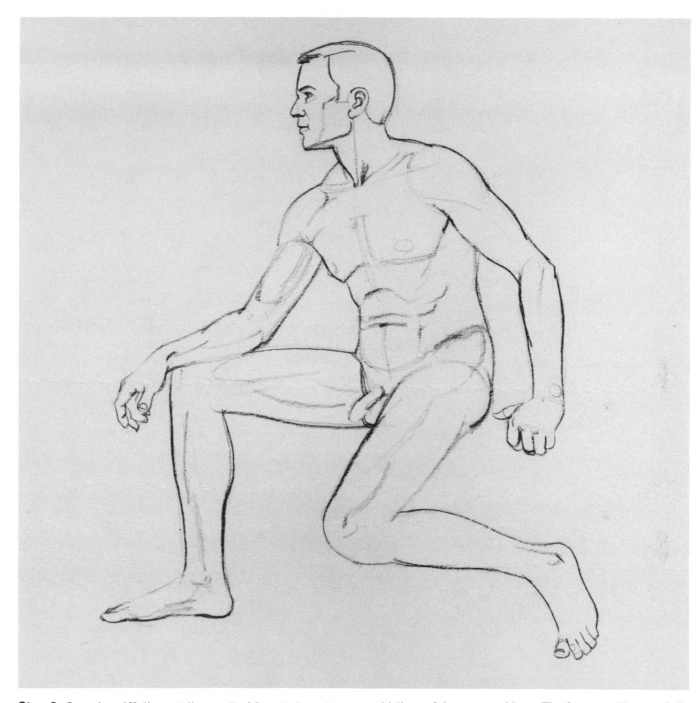

Step 2. Over the stiff, linear "diagram" of Step 1, the artist draws the lifelike curves of the body. The facial features and the anatomy of the neck are drawn faithfully over the original guidelines. The guidelines of the torso are followed to align the shoulders, draw the rectangular shapes of the chest muscles, and locate the navel and the abdominal muscles. The bulges of the muscles are placed over the original guidelines of the arms and legs. The feet are still essentially wedge-shaped, but the artist has rounded the heels, accentuated the bulge behind the toes, and drawn the individual toes. In the foot on the right, notice how the toes follow the curve of the guideline of Step 1. And study how the simple, blocky shapes of Step 1 have been converted into fingers—again following the original guidelines faithfully.

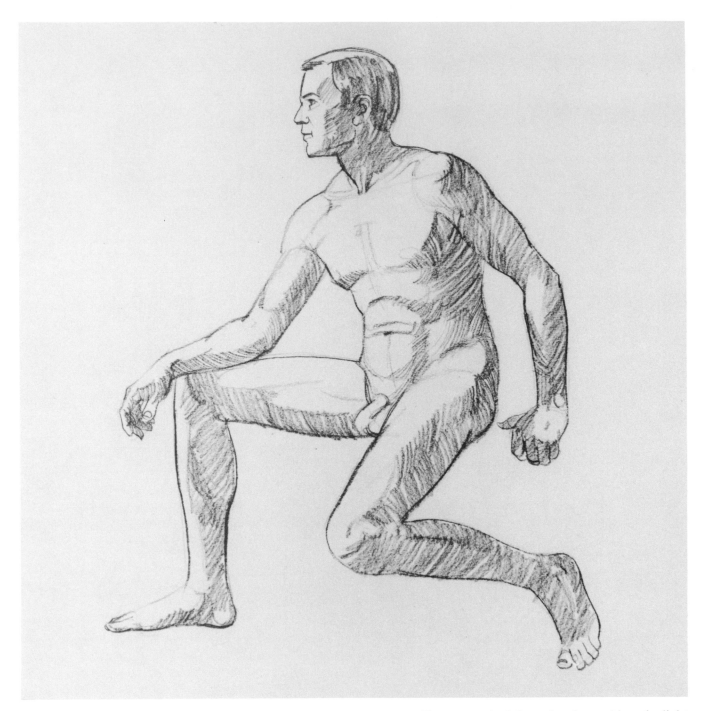

Step 3. The artist observes the direction of the light, which comes from the left and from slightly above. Thus, the right sides of the shapes, and the undersides, are in shadow. The artist blocks in the broad shadow areas with the pencil held at an angle to the paper so that the side of the lead makes broad strokes. The shadow runs down the brow, cheek, and jaw. Because the light comes from slightly above, the chin throws the entire neck into shadow. The tops of the shoulders, as well as the front planes of the chest muscles, rib cage, and abdomen turn up and meet the light. The undersides of the chest muscles and rib cage, as well as the side planes of the abdomen and the entire torso, turn away into shadow. The arm on the left reaches forward into the light, and so all of the undersides of the shapes are in shadow. But the arm on the right leans back, away from the light, and so the shapes are mainly in shadow, except for the bulge of the forearm and the back of the hand, which turn upward and receive the light. On the leg at the left, the top plane of the thigh and foot, as well as the front plane of the lower leg, turn toward the light; the underside of the thigh and foot, as well as the back plane of the lower leg, turn away into shadow. On the leg on the right, only the top plane of the thigh faces the light, while the rest of the leg is in shadow.

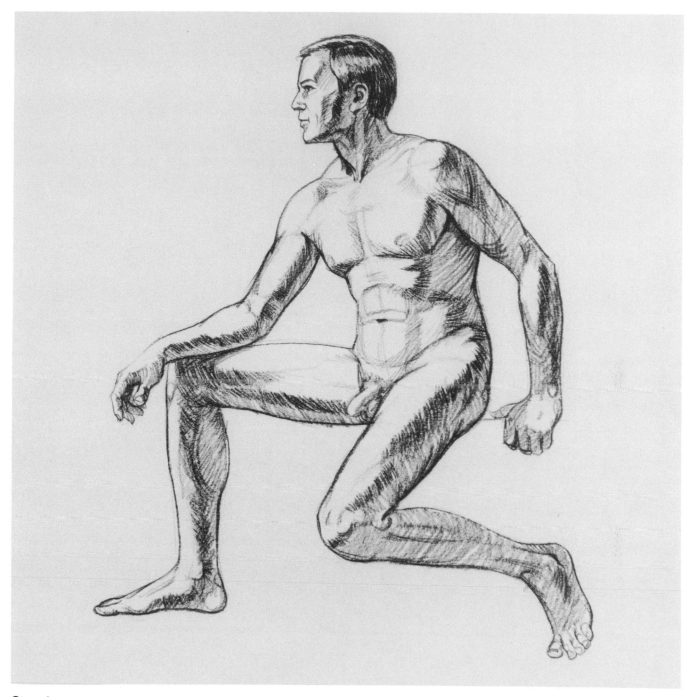

Step 4. In the final stage, the artist darkens all the tones of the figure with the side of the lead, building up these tones with parallel strokes. With the sharp point of the pencil, he accentuates all the linear contours of the shapes. In the completed drawing, we see the four essential tones that produce a round, three-dimensional figure. Bare paper represents the sides of the forms that face the light: the front of the head and the top and front planes of the shoulders, chest, abdomen, one arm, the thighs, and one lower leg and foot. Within these lighted planes, the anatomical details are suggested by half-tones—clusters of pale pencil strokes. As the backs and the undersides of the forms turn away from the light, we see the shadows—the darkest tones in the drawing. And as the forms continue to turn away from the light, the shadows grow slightly paler as they pick up reflected light from some remote light source, such as a distant window.

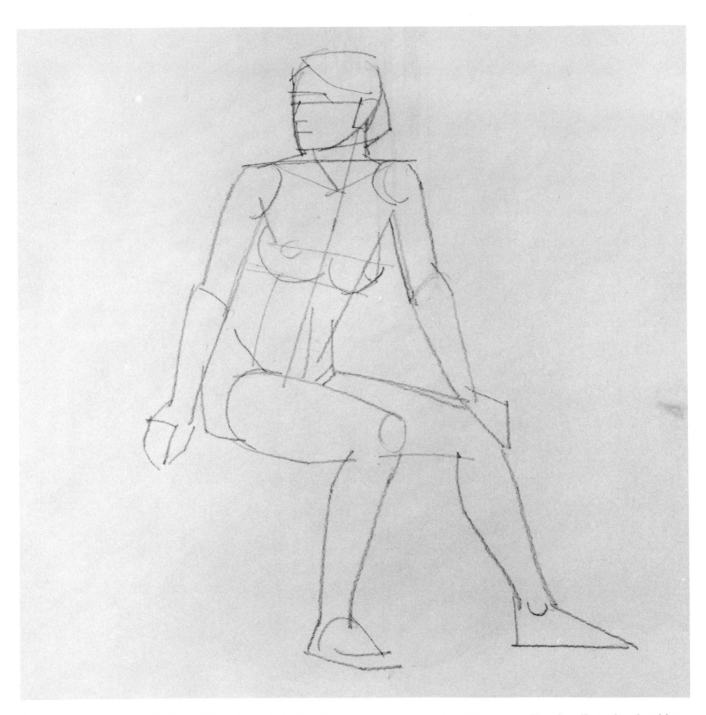

Step 1. By now, the guidelines of Step 1 should be familiar to you. The egg shape of the head is crossed by guidelines that locate the eyes, nose, and mouth, as well as the ear, which aligns roughly with the eyes and nose. On the tapering, rectangular shape of the torso, a center line drops from the pit of the neck to the navel and the unseen crotch. Horizontal guidelines connect the shoulders and locate the nipples and the undersides of the breasts. The artist omits the guideline that locates the navel, but he sees it in his mind's eye, as *you* should by now. He visualizes the shoulders, breasts, and knees as circular forms. The upper and lower arms are tapering cylinders, while the hands are blocky shapes, divided into two planes at the knuckles where the fingers meet the back of the hand. The legs are also tapering cylinders, with a slight bulge for the calf muscles. The feet are triangular, with a circular guideline to suggest the bulge of the anklebone.

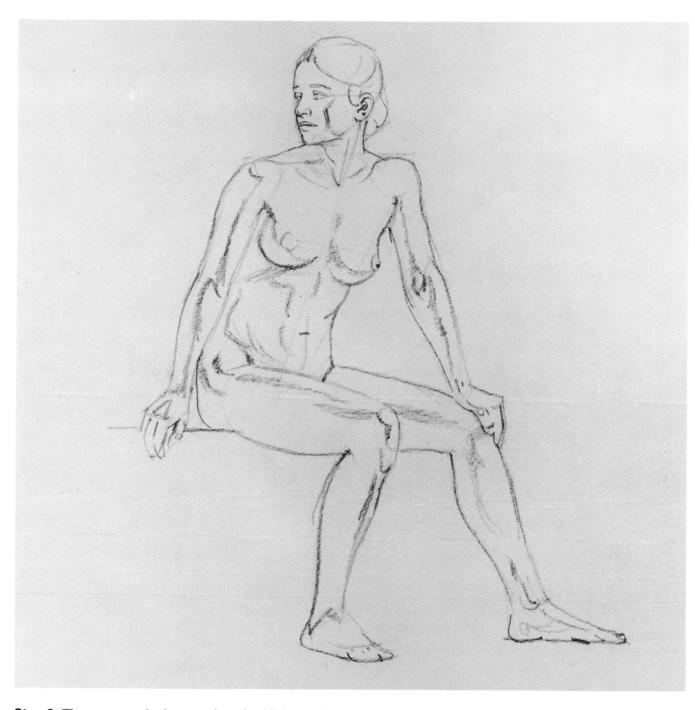

Step 2. The next stage in the procedure should also be familiar. The artist draws the curves of the living figure over the stiff lines of the "diagram" of Step 1, and then he begins to erase those guidelines. Within the shapes, he suggests the edges of shadows which will appear in Step 3. Whenever you draw the figure, it's important to watch the alignments of the forms. Which forms align with which, either horizontally or vertically? And which alignments are unexpected, but nevertheless accurate? For example, in this pose, the shoulder on the right seems unexpectedly high, and it's important to figure out why. The model is leaning forward, resting one hand on her knee and putting the weight of her torso on that arm alone, thus forcing the shoulder upward. The alignment of the shoulders often varies in this way, depending upon where the model places the weight of her body.

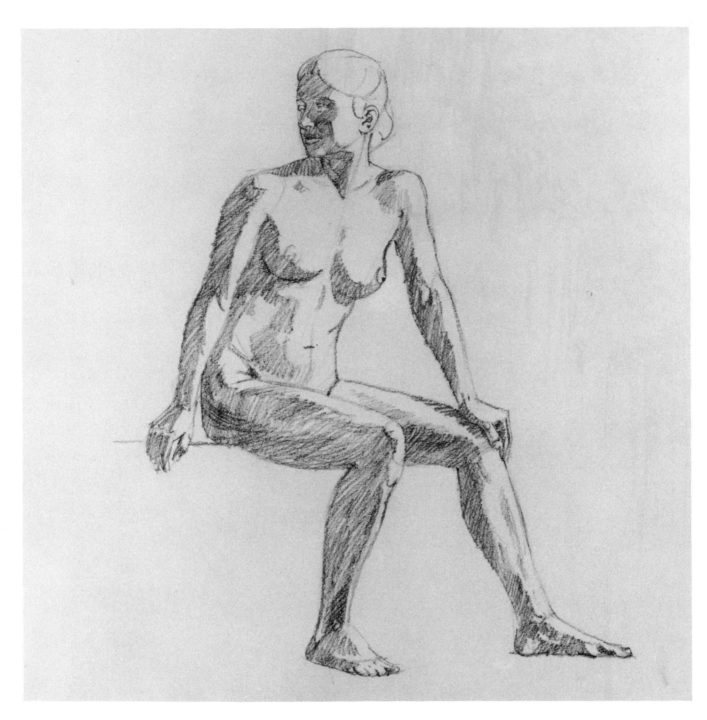

Step 3. The artist observes that the light is coming from the upper right. The tops and right sides of the forms face the light, while the left sides and undersides turn away into shadow. You can see this most clearly in the head, where the face turns away from the light and all the features are in shadow; the light strikes only one side of the forehead, cheek, and jaw, as well as the ear and the very tip of the nose, which juts out of the shadow to pick up a small triangle of light. In the same way, the breasts turn upward and receive the light, but their undersides curve downward and away from the light, producing crescent-shaped shadows. The artist blocks in all the shadow shapes with the side of the lead, holding the pencil at an angle to the paper.

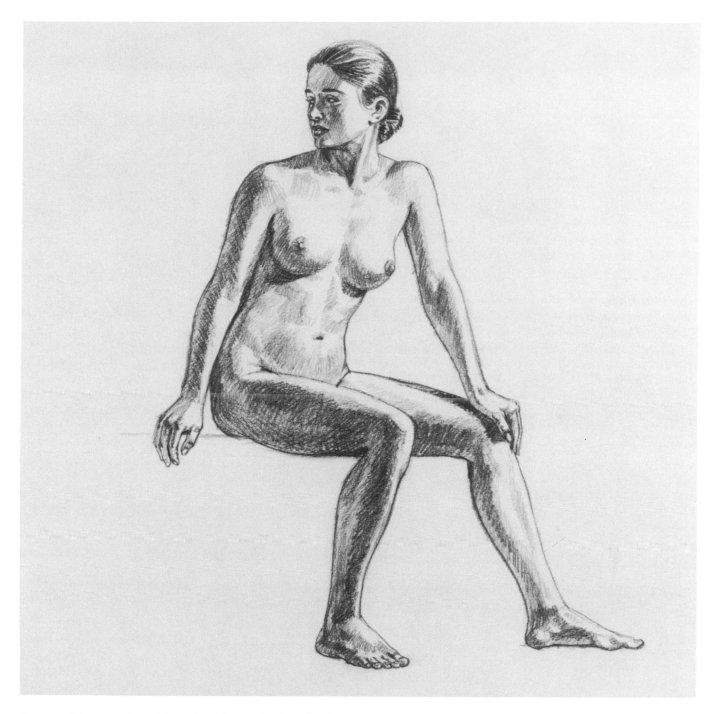

Step 4. The completed drawing shows the four basic tones—light, halftone (or middletone), shadow, and reflected light—as well as a fifth tone that appears frequently, the cast shadow. You can see the gradation of four tones very clearly on the thigh at your left: the lighted top of the thigh, curving downward to a hint of halftone that quickly merges with the shadow, and finally the reflected light within the shadow along the lower edge of the thigh. You can see a similar gradation on the breasts, whose rounded forms cast dark shadows downward over the rib cage. Remember that the tones within the lighted planes are usually halftones—distinctly paler than the darks on the shadow side of the figure.

Slender Strokes. A simple and effective way to draw with the common graphite pencil is to work entirely with the sharpened point. The point draws the contours of the shapes and then blocks in the tones with slender strokes, drawn in parallel clusters like those you see here. To darken the tones, you can build stroke over stroke or just press harder on the pencil. To accentuate the roundness of the figure, the pencil strokes curve with the forms. The individual strokes "mix" in the eye of the viewer to create a sense of light and shade.

Broad Strokes. An equally effective way to draw the same subject is to turn the pencil at an angle to the paper and draw with the *side* of the lead, producing broader strokes than you can make with the sharpened tip. Or you can take a thick, soft pencil in the 4B–6B range and shape the lead to a broad, blunt point that makes wide strokes. The pencil behaves something like a flat brush, depositing large areas of tone with just a few strokes. Press harder or place one stroke over another to produce a darker tone like the edge of the shadow on the arm or the cast shadow beneath the breast.

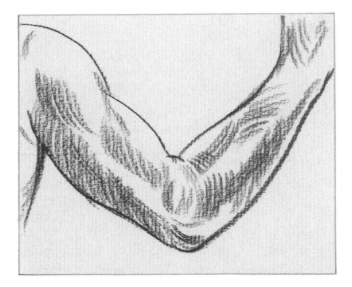

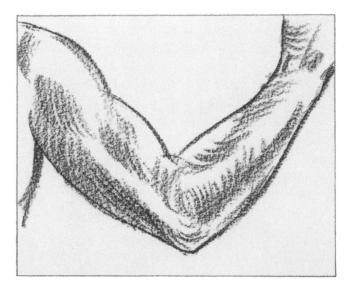

Strokes on Charcoal Paper. The delicately ribbed surface of the charcoal paper is just as effective for pencil drawing as it is for charcoal. The *tooth* of the paper, as it's called, breaks up and softens the stroke. Tiny flecks of bare paper show through the strokes. On smoother paper, these bold strokes, made with the thick lead of a 4B pencil, might look harsh; but they look subtle and luminous on charcoal paper. Charcoal paper has a remarkable way of adding vitality to the pencil stroke.

Strokes on Rough Paper. There are much rougher papers than charcoal paper. The pebbly texture of rough paper tends to break up the pencil stroke into a granular tone that looks rich and luminous because of all the tiny dots of bare paper that show through. The ragged tooth of the paper also forces you to work with big, bold strokes. Slender, elegant lines and precise details won't work on this drawing surface. It's good experience to work on rough paper because the drawing surface forces you to work boldly and simply. A few big, decisive strokes must do the job.

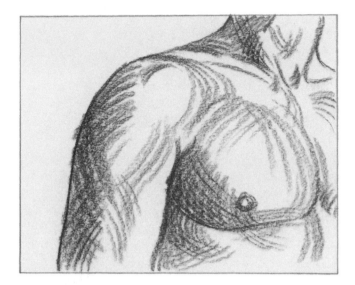

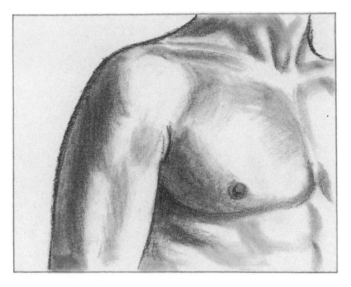

Modeling with Strokes. Modeling is the process of building up tone to create the illusion of three-dimensional form. (The term *modeling* is derived from sculpture, as you might guess.) One method is to build up a pattern of pencil strokes that move over and around the forms the way a sculptor's chisel moves over and around the stony shapes. In this drawing, notice how the artist uses the side of the lead to render halftones and shadows with curving strokes that follow the roundness of the chest and shoulder muscles.

Modeling by Blending. A different way to build up light and shade is to begin with pencil strokes and then blend these strokes together with your fingertip or a paper stomp. In this study, the artist begins by letting the side of a 2B lead glide lightly over the paper. Then he moves his fingertip back and forth over the paper, smudging the pencil strokes until they merge into soft tones. He alternates between these two drawing tools—the pencil and his fingertip—gradually adding more strokes and blending them until he achieves the full tonal range.

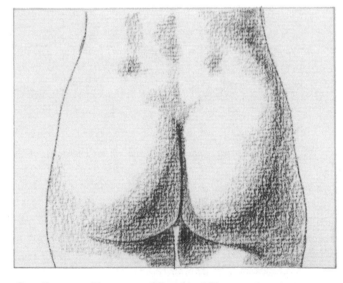

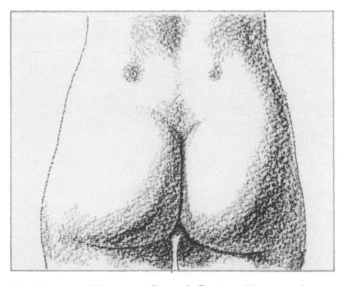

Continuous Tone on Charcoal Paper. Another way to create soft, sculptural tones is to move the pencil lightly back and forth over the textured surface of charcoal paper, never pressing hard enough to register a distinct stroke, but simply letting the tooth of the paper shave off the granules of graphite—as if the charcoal paper were a very fine grade of sandpaper. As the pencil glides back and forth over the same area, the tone gradually darkens as the paper shaves off more granules of graphite. The gradual buildup of tone gives the drawing its beautiful rounded form.

Continuous Tone on Rough Paper. You can do exactly the same thing on any paper that has a distinct tooth. Rough paper will shave off the granules of graphite more rapidly, of course, so it takes fewer back-and-forth movements of the pencil to build up the tones. It's important to know when to stop. Just a few movements of the pencil are enough to produce the halftones—don't let them get too dark. And just a few more movements of the pencil, with a bit more pressure, will produce the darks.

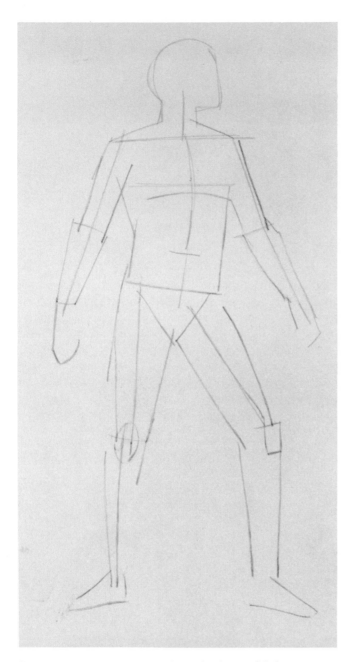

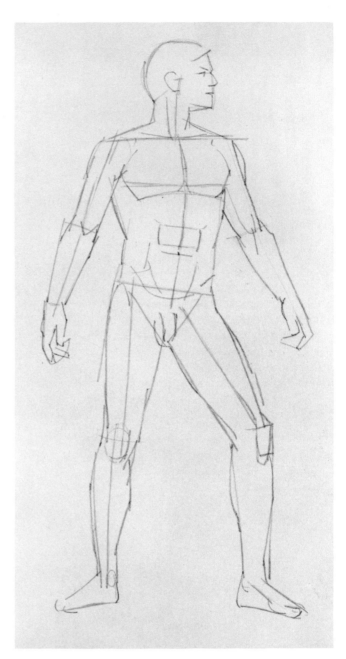

Step 1. When you begin to draw the figure, it's best to start with a simple standing pose in which it's easy to see all the shapes clearly. And it's worthwhile to start with the simplest pencil drawing technique—drawing the contours with the sharpened tip of the pencil and building up the tones with clusters of slender strokes. In this demonstration, the artist begins with the familiar guidelines. The "diagram" of the male figure consists mainly of simple straight lines. At this stage, the drawing is only a bit more elaborate than the "stick figure" that children draw. This "diagram" is worth memorizing because it's a very efficient, functional way to start a figure drawing.

Step 2. The artist uses the guidelines of Step 1 as a kind of map over which the point of the HB pencil travels to construct the living forms of the figure. Always study the alignments of the forms at this stage. Some alignments remain essentially the same, like the *landmarks* (as artists call them) along the center line of the torso: the pit of the neck, the division between chest muscles, the navel, and the crotch. But every pose also has its own unique set of alignments. If you get these right, the drawing will be accurate. For example, in this pose, the shoulders fall directly above the heels, the hands are directly above the toes, and the center line of the torso continues downward along the inner edge of the leg on the left.

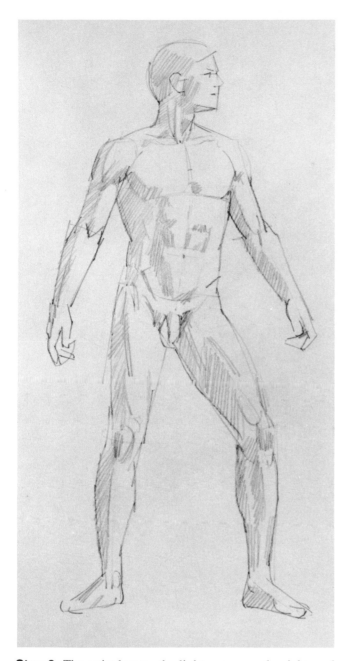

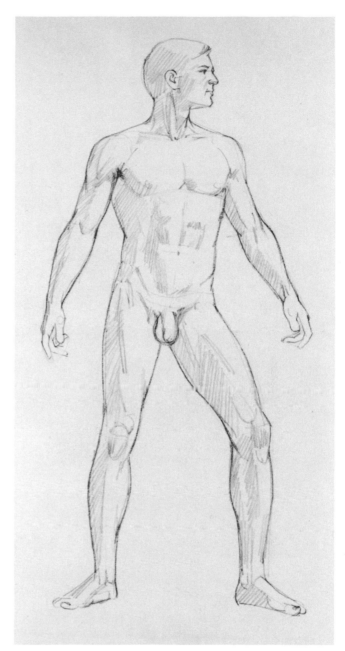

Step 3. The artist locates the light source on the right, and so he builds up the shadows on the left sides of the forms. He works with slender parallel strokes in clusters. At this stage, his purpose is just to establish simple divisions between the lighted planes and the shadow planes of the figure. However, he bears in mind that each shadow has its own distinct shape, which it's important to record accurately. For example, the shadows on the sides of the limbs tend to be long, slender strips, but along the inside of the thigh on the right, the shadow is a zigzag shape. The shadows curve around the shoulder and chest muscles.

Step 4. Up to this point, the artist has been working with simplified, rather angular lines to define the contours of the figure. Having established these essential outlines, and the shapes of the shadows, he now begins to refine them with curving lines that make the body more lifelike. Working with the sharp point of the HB pencil, he develops the features and the facial contours, and then he works downward to redraw the outlines of the shoulders, torso, arms and hands, and legs and feet. He concentrates on the outer edges of the forms. The inner shapes will come next.

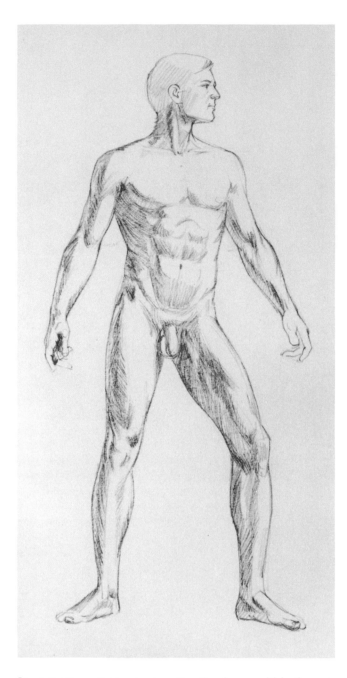

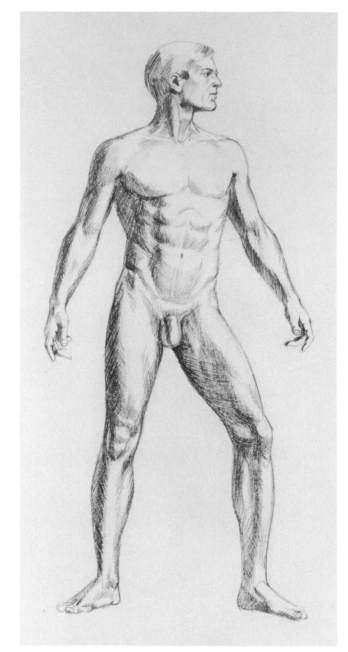

Step 5. The artist begins to refine the shapes within the outline by building up the tones. In Step 2, he indicated the tones with parallel straight lines that merely define the shapes of the shadows. Now he works with clusters of strokes that follow the curves of the forms. The angular shadow shapes of Step 3 are gradually converted into rounded ones as the artist models each muscle or muscle group. Look again at the zigzag shape of the shadow on the thigh in Step 3 and see how this is developed in Step 5. For the first time, you also begin to see some suggestions of the distinctions between halftone, shadow, and reflected light.

Step 6. Building stroke over stroke, the artist continues to darken the tones. He works with clusters of strokes, running a series of parallel strokes around the curve of the chest muscle, for example, or down the edge of the leg. He doesn't just place a stroke here and there, at random, but works over the entire shape of the shadow so the strokes become masses of tone. He also begins to sharpen the contours and details of the head, hands, and feet. Notice how one shadow shape flows into another, such as the continuous strip of tone that runs down from the shoulder to the arm on the left, or the long series of interlocking shadows that start at the armpit and continue down to the ankle on the left.

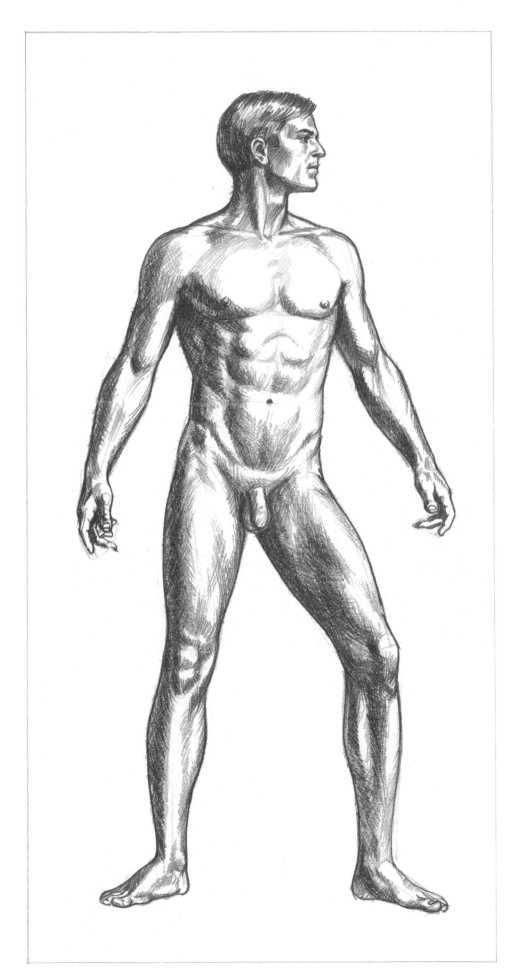

Step 7. In the final stage, the artist builds up the tones to their full richness, gradually piling stroke over stroke in the shadow areas and using halftones to suggest anatomical details within the lighted areas—particularly in the chest and abdomen. Now you see the full range of lights, halftones, shadows, and reflected lights. The sharp point of the pencil moves over the entire figure, accentuating all the outlines and defining such details as the facial features, fingers, and toes. Until now, all the figure-drawing demonstrations have taken you through four essential stages: drawing the preliminary "diagram" of the figure; constructing a lifelike line drawing over it; blocking in the tones; and finally, building up the full range of tones and redefining the outlines. However, as you see in this seven-step demonstration, there are many operations within these four basic steps. Like the demonstration you've just seen, the remaining demonstrations in this book will break these operations down into seven stages so you can follow the drawing process in greater detail.

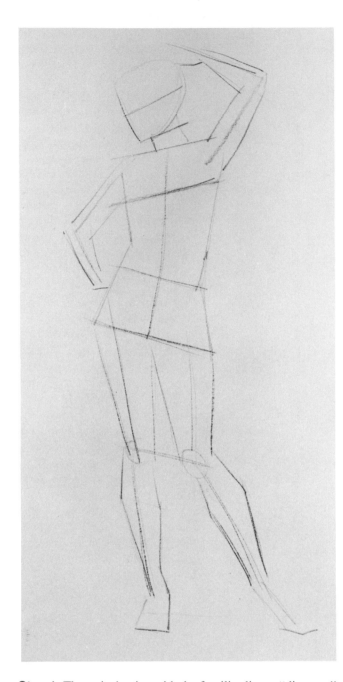

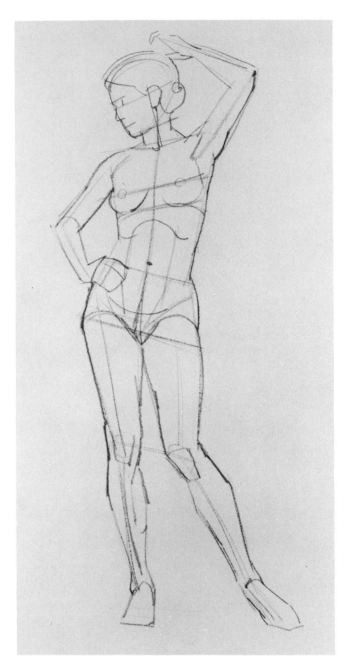

Step 1. The artist begins with the familiar linear "diagram" of the model. But the guidelines reveal some important changes in the alignments of the forms. The model's weight rests on the foot at the left, while the other foot carries less weight. At the same time, one arm bends at the elbow while the hand rests on the hip, and the other arm is raised as the model's hand adjusts her hair. All the shapes tend toward the diagonal. Thus, the guidelines show that one hip is higher than the other in this pose. In the same way, the guidelines at the shoulder and nipples show that one shoulder is higher than the other.

Step 2. When the artist constructs the contours of the living figure over the "diagram" of Step 1, these new alignments become even more obvious. The center lines of the torso, arms, and legs are all slanted ones—which the artist follows faithfully in drawing the slanted movements of the forms. There are also some surprises in the vertical alignments. On the left, the shoulder, knee, and ankle all line up above one another. On the right, however, it's the elbow that's directly above the ankle, while the shoulder is directly above the knee. The nipples are directly above the knees, but one knee is higher than the other. Always look for these alignments when you construct a figure.

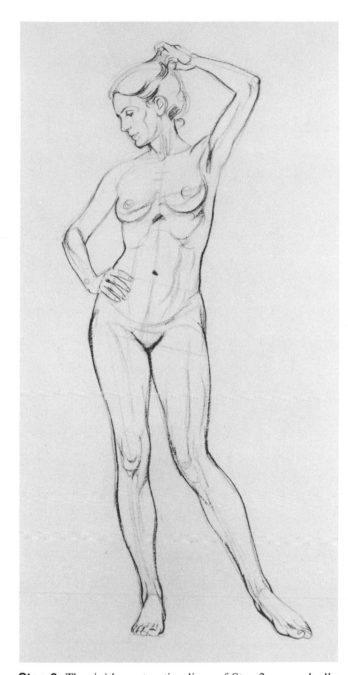

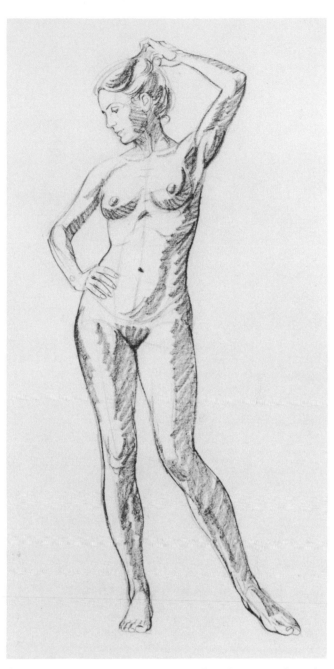

Step 3. The rigid construction lines of Step 2 are gradually erased as the artist draws the curves of the living figure. In these early stages, the artist works with the sharpened point of an HB pencil, moving his whole arm rhythmically—and so the lines are fluid and rhythmic too. To capture the grace of the model, the artist looks for lines that flow into one another. For example, notice how the inner line of the up-raised arm continues down into the chest muscle and from there into the curve of the breast. In the same way, the inner curves of the thighs sweep around the knees and down into the lower legs in a series of interlocking S-curves.

Step 4. In contrast with the preceding demonstration, the artist builds his tones with broad strokes, made with the side of the lead as he holds the pencil at an angle to the paper. He also switches from an HB to a 2B pencil. Working with groups of parallel strokes, he moves rapidly down the forms, observing the shapes of the shadows and filling them with tone. The light comes from the left and from slightly above, and so the right sides of the forms are in shadow, as are the undersides of shapes such as the breasts, abdomen, and knees. He studies the shapes of the shadows carefully, such as the S-curve of the shadow that travels upward from the abdomen to the rib cage, and the crescent shapes of the shadows beneath the breasts.

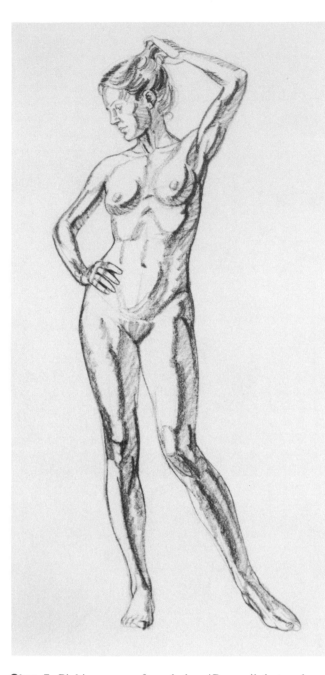 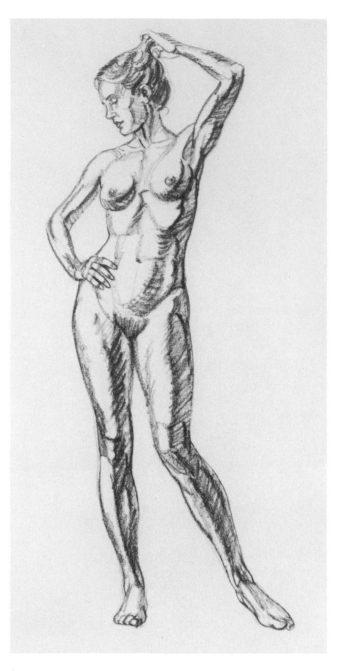

Step 5. Picking up a softer, darker 4B pencil that makes a thick stroke, the artist starts to deepen the shadows. With the broad side of the lead, he darkens the edge where each shadow meets the light, and so now we see shadow *and* reflected light on the dark side of each form. With the sharpened point of the soft, dark pencil, he begins to sharpen the details of the head. Then he refines certain contours, such as the arms, the hips, and the shadow side of the torso.

Step 6. Still working with the thick pencil, the artist continues to build up the shadows with short, curving strokes that wrap around the forms. You can see these strokes most clearly within the shadows on the raised arm, breasts, rib cage, abdomen, thighs, and lower leg. With the tip of the pencil, he accentuates such details as the features, nipples, and toes. We begin to see the full gradation of tones.

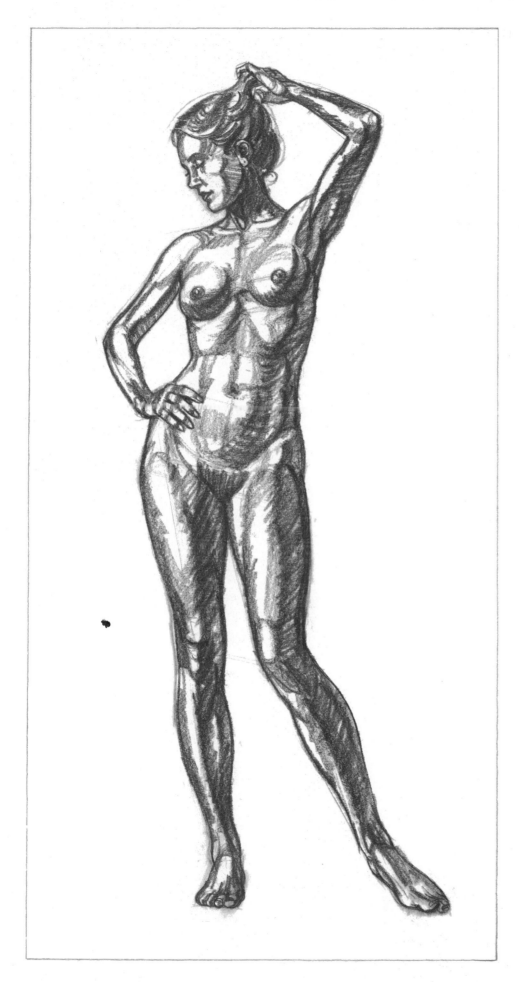

Step 7. The artist deepens the tones of the shadows with short, curving strokes, made by using the side of the 4B lead. (The rich, dark tones of the soft pencil are ideal for building up strong lights and shadows.) Then he moves into the lighted areas to develop anatomical details such as the rib cage, abdomen, and thigh muscles with halftones. Sharpening the pencil point on a sandpaper block, he again goes over the outlines of the figure to define them more precisely. He reinforces the details of the features, hands, and feet. Compare the broad-stroke technique of this demonstration with the slender strokes used to develop the tones of the preceding demonstration. Try both methods to explore the full range of pencil-stroke techniques. And keep drawing simple standing figures to memorize the basic forms of the male and female bodies. Then, when you feel ready, go on to more complex poses.

Step 1. A seated figure is still fairly easy to draw and is a good pose to try next. In this demonstration, the artist shows you how to use slender pencil lines for the contours, plus a combination of broad strokes and blended tones for the modeling of the light and shade. The preliminary "diagram" includes most of the usual guidelines, omitting a few that the artist obviously carries in his head. As you've seen by now, every pose has its own unique set of alignments. The corner of the near shoulder aligns vertically with the curve of the buttock and the heel. The corner of the far shoulder is directly above the corner where the torso meets the far thigh. The elbow of the straight arm comes down to the waist, but the elbow of the bent arm is above the waist.

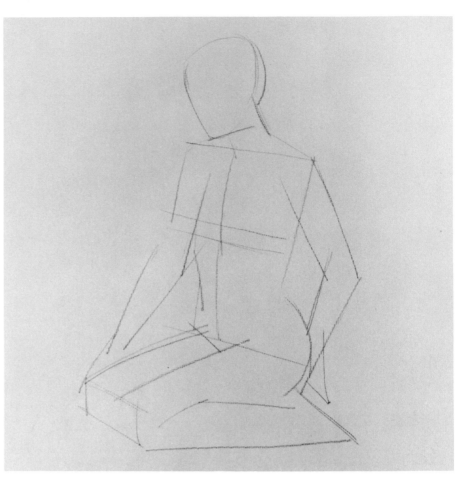

Step 2. When the artist constructs the forms of the body over the "diagram," other alignments become apparent. The inner curve of the near shoulder is directly above the angle of the waist. The model's nose is directly above the corner of the far shoulder, while her ear is directly above the pit of the neck. The back of the model's neck is a slanted line that runs parallel to the lines of the upper arm on the right. Even when you draw a relatively simple pose like this one, look for these relationships; they're the key to achieving accurate proportions and capturing the "movement" of the pose.

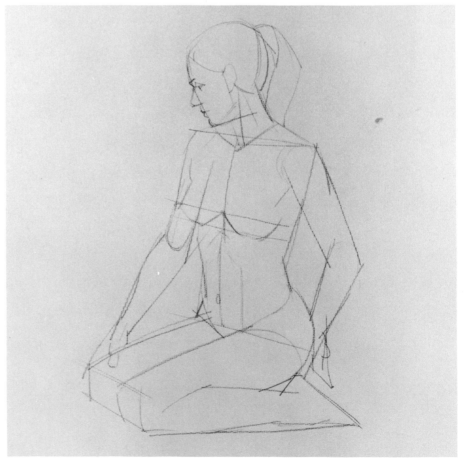

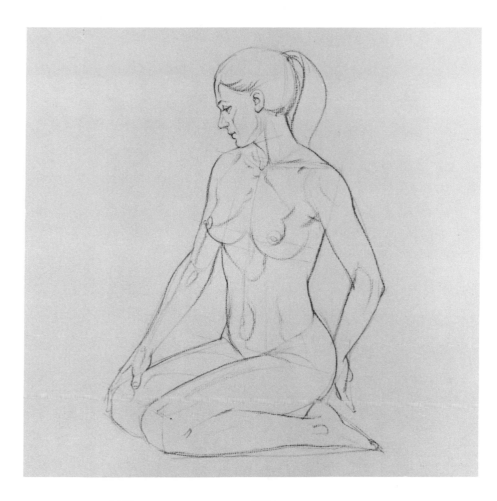

Step 3. As he draws the lifelike contours of the figure over the construction lines of Step 2, the artist not only studies the model for anatomical accuracy, but also looks for the connections *between* the lines. Notice how the line at the back of the model's neck flows into the curve of the shoulder and then down into the contour along the back of the upper arm. The artist also looks for more subtle connections between lines, such as the upper edge of the near thigh, which flows around into the waistline. The actual line that links the thigh and waist will disappear beneath the modeling of Step 4, but the viewer will still sense the connection without knowing it. These connections between lines, sometimes visible and sometimes invisible, give the figure a feeling of internal rhythm and grace.

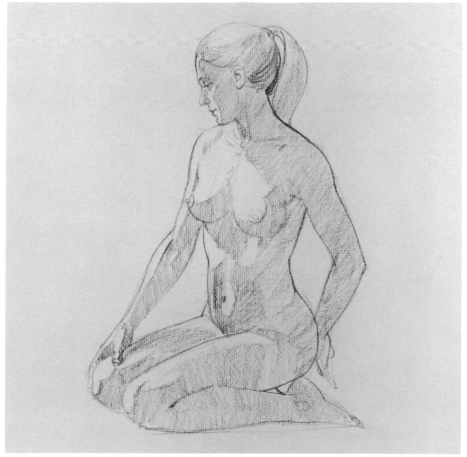

Step 4. Up to this point, the artist has been working with the sharp point of a 2B pencil. Now he picks up a thick, soft 4B pencil—he could also use a stick of graphite—and holds the drawing tool at an angle to block in the tonal areas with broad strokes. Now it's obvious that he's working on a sheet of charcoal paper, which lends its distinct texture to the strokes. The light comes from the left and is somewhat behind the model, and so most of the figure is in shadow. There are just a few patches of light. Each patch of light and shadow has its own distinct shape, which the artist observes and draws carefully. Look back at Step 3 and you'll see that the line drawing includes the edges of these light and shadow shapes.

Step 5. The artist moves a fingertip lightly back and forth over the shadow areas to blend the tones. Charcoal paper has a hard surface that allows the fingertip—or a stomp—to glide smoothly over it and push the graphite around like wet oil paint. The artist doesn't want to obliterate the strokes of Step 4 completely, and so he moves his finger lightly over the paper, softly merging the tones but allowing some of the strokes to show. He darkens the abdomen and breasts with a few more strokes and blends them softly to accentuate the roundness of the forms. With the sharp point of the 2B pencil, he strengthens a few contours, such as the back of the neck and the waistline.

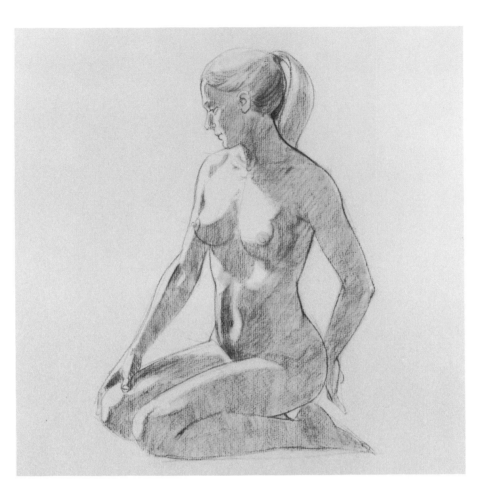

Step 6. Working with the soft, dark 4B pencil again, the artist begins to build up the darks with clusters of parallel strokes. He emphasizes the dark edges of the shadow shapes where they meet the light. You can see this effect most clearly on the cheeks, the straight arm, the breasts, and the abdomen. The shadow shapes glow with rich darks and reflected lights. The sharp point of the 2B pencil begins to reinforce the features, the texture of the hair, the lines of the neck, the hands and foot, the line of the straight arm, and the curves of the chest muscles.

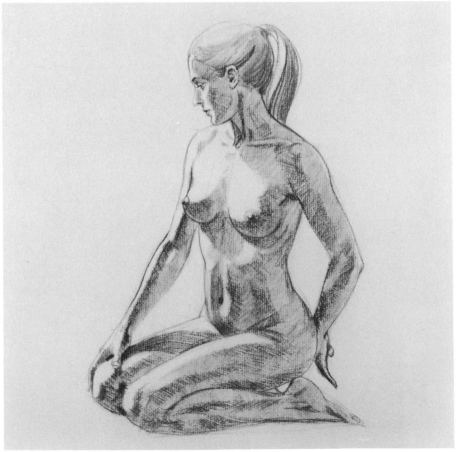

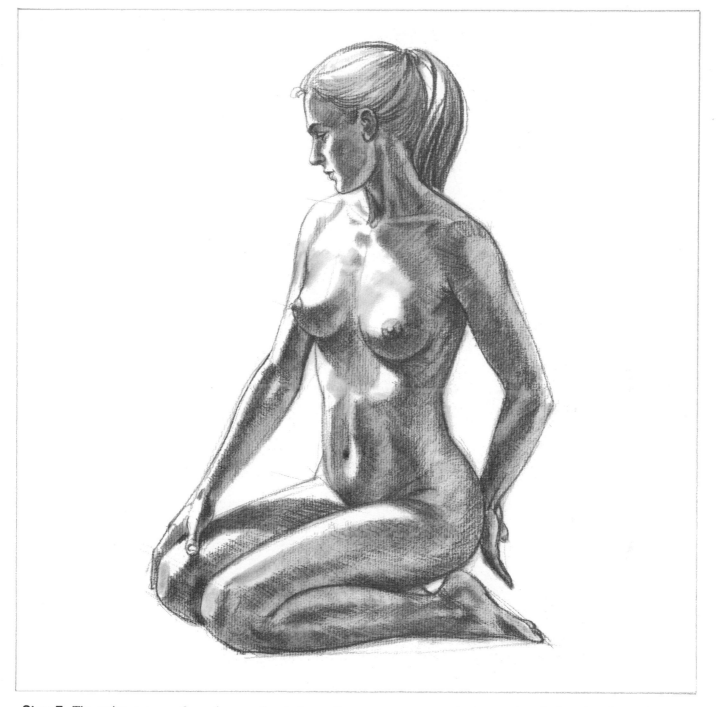

Step 7. The artist moves a fingertip over the dark pencil strokes of Step 6 to blend them into the shadows. Within the shadows, the darks and the reflected lights now flow together more smoothly. Wherever an area needs darkening, the artist first adds a few broad strokes with the 4B pencil and then merges them with his fingertip. However, he doesn't fuse all the strokes, but often allows them to remain intact; you can see these strokes most clearly on the thigh and calf of the leg, where the artist uses unblended strokes to build up anatomical detail. Wherever he wants a particularly strong dark note, he leaves the strokes unblended, as you can see in the curving shadow that the straight arm casts over the lighted top of the thigh. For touches of halftone such as the soft grays on the chest, the artist simply presses his graphite-coated fingertip against the bare paper. Finally, the sharp point of the 2B pencil moves around the contours of the figure to sharpen the lines. The point of the pencil also accentuates the features, adds a bit more detail to the hair, and focuses on such precise details as the nipples, fingers, and toes. It's always best to save these details for the very end.

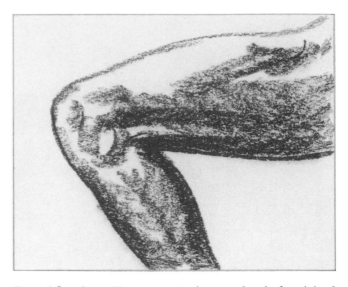

Slender Strokes. You can sharpen a stick of chalk on a sandpaper pad to make slender, precise strokes. Even if you don't bother to sharpen that rectangular stick of chalk, you can make fairly crisp strokes with the sharp corner of the stick. Or you can buy chalk in the form of a pencil that will make even more precise lines. This close-up of a muscular leg is drawn with the sharpened tip of a Conté crayon. The artist first draws the outer contours of the leg with a few decisive strokes. Then he builds up the tones within the leg with clusters of parallel strokes.

Broad Strokes. The square, unsharpened end of a stick of hard pastel will make bold, broad strokes. Here, the artist uses the sharp corner of the rectangular stick to draw the linear contours of the leg. Then he uses the square tip to build up the tones with wider strokes. The chalk moves lightly over the paper to produce the paler tones, and presses harder for the darks along the undersides of the forms. Hard pastel breaks easily; build up the darks by moving the chalk back and forth over the paper several times—don't apply too much pressure to the stick.

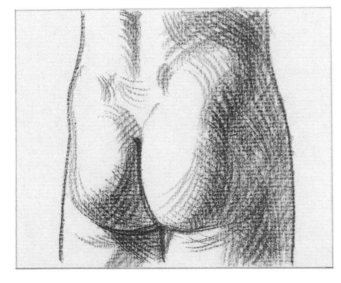

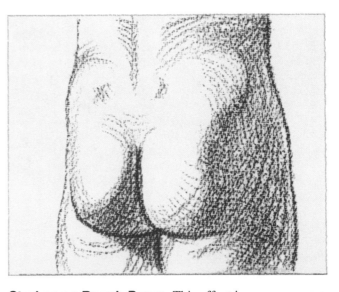

Strokes on Charcoal Paper. Chalk or pastel in pencil form will make precise strokes like those you see in this study of muscular male buttocks. However, the texture of charcoal paper will soften and break up the strokes so that they seem to blend—even though the strokes aren't actually touched by a fingertip or a stomp. If the artist builds one curving stroke over another, the texture of the paper has a unifying effect: the strokes merge and become masses of tone.

Strokes on Rough Paper. This effect is even more pronounced on rougher paper. As the chalk pencil moves over the ragged surface of the sheet, the pebbly texture of the paper takes over. The individual stroke loses its identity and merges with the other strokes to form a rough, granular tone. The rich tonal effect is achieved without blending. The strokes seem to "mix" in the eye of the viewer.

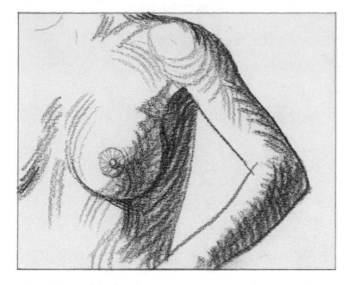

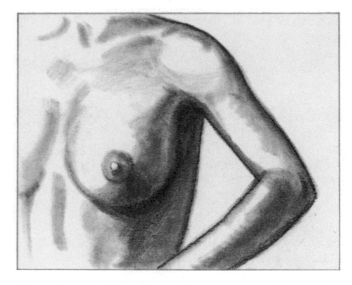

Modeling with Strokes. The blunt end of a stick of chalk builds up the tones with thick, curving strokes that follow the rounded contours of the forms. Notice how the strokes on the forearm, for example, actually curve around the cylindrical shape. In the same way, the strokes of the chalk wrap around the torso and breast. The artist piles one curving stroke over another to create stronger darks. The rounded, three-dimensional forms are created entirely by this buildup of curving strokes.

Modeling by Blending. Those same strokes can be blended with a fingertip or a paper stomp to create smooth, velvety tones. The artist begins by blocking in the tones with broad strokes, which he then merges with a back-and-forth movement of his fingertip. To strengthen the darks, he adds more strokes and blends these too. The stomp is used to get into tight corners, such as the shadowy armpit. A kneaded rubber eraser lifts away unnecessary tones to brighten the lighted areas. And the sharp corner of the rectangular chalk reinforces the contours with dark, slender lines.

Continuous Tone on Charcoal Paper. A sheet of charcoal paper has an intricate pattern of peaks and valleys. If you move a stick of chalk—or chalk in pencil form—lightly over the paper, the drawing tool hits only the peaks and skips over the valleys. If you don't press too hard and keep moving the drawing tool lightly back and forth, not a single stroke will show, but the granules of chalk will slowly build up. Rich, luminous tones will magically emerge, like the lights and shadows on this close-up of a female torso.

Continuous Tone on Rough Paper. You can achieve the same effect on any sheet of paper that has a pronounced tooth. The rougher the paper, the more quickly the tones will build up as you move the chalk back and forth, hitting the jagged peaks and skipping over the valleys. The blunt end of the chalk is used to build up the tone, while the sharp corner of the rectangular stick draws the linear contours of the hips.

Step 1. A bending male figure—only a bit harder than an upright pose—will give you an opportunity to draw a complete figure in chalk. For this demonstration, the artist chooses a cylindrical stick of chalk in a plastic holder. The chalk is fairly thick, but it's easily sharpened on a sandpaper pad to make the slender lines of the preliminary "diagram." You'll notice that the guidelines are growing simpler. By now, many of these lines should be in your head; there's no need to place them all on paper unless you feel that they're necessary for a particular pose. Notice that nearly all the lines in this pose are diagonals; this is usually true when the model takes an active pose. The shoulder that leans forward is almost directly above the jutting knee of the leg on the left. The high shoulder on the right is above the crotch, while the elbow of the arm that swings backward is directly above the hip. An active pose won't be hard to draw if you record all these relationships correctly.

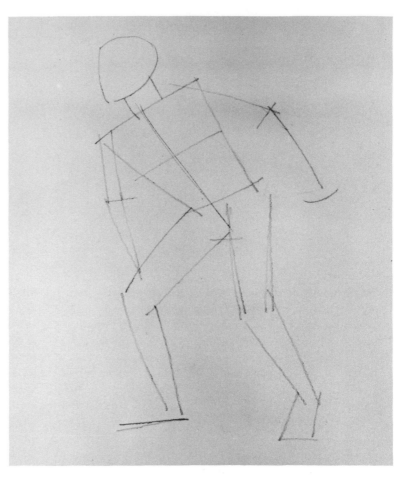

Step 2. When the artist constructs the forms of the figure over the "diagram" of Step 1, he reveals other relationships between the forms. The clenched fist is directly above the heel on the right, while the head is directly above the foot on the left. The undersides of the chest muscles align with the elbows of both arms, while the line of the crotch aligns, more or less, with the wrists. Although many alignments change with the pose, others tend to stay the same—and these are important too. For example, the guidelines that cross the torso to connect the shoulders, chest muscles, and hips are usually (though not always) parallel. And the pit of the neck, the division between the chest muscles, the navel, and the crotch *always* fall on the center line of the torso, even though that center line may curve slightly in some poses.

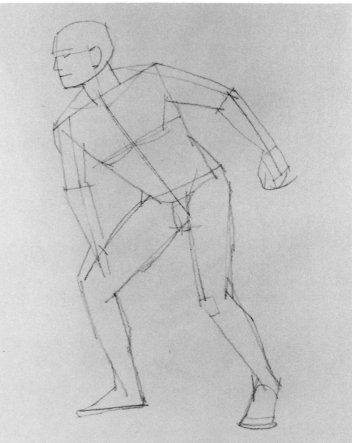

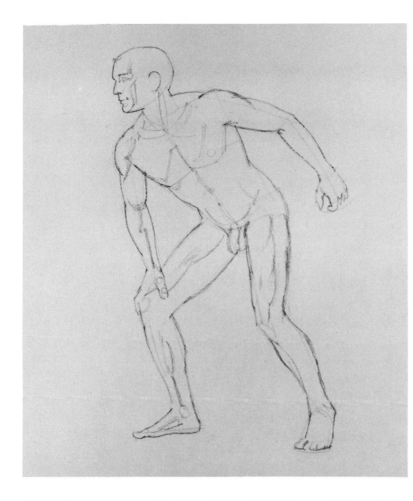

Step 3. As usual, the artist executes a realistic line drawing of the figure over the construction lines of Step 2. He's still working with the sharpened tip of the cylindrical stick of chalk. The thick chalk doesn't make as neat a line as a graphite pencil, but the ragged line has its own kind of beauty. The angular contours of Step 2 become rounded, lifelike shapes in this step. To capture the vitality of the figure, the artist looks for lines that flow—or *seem* to flow—into one another. On the right side of the figure, for example, a single, rhythmic contour flows from the armpit, down along the torso, around the thigh, and down the lower leg to the heel, where the line finally ends at the angular, bony shape. It's also important to watch for those places where one contour overlaps another, signifying the fact that one form comes forward while the other goes behind it. At the right, the rounded bulge of the shoulder comes forward, while the contours of the muscles on either side move behind the bulge. These overlapping contours enhance the drawing's three-dimensional quality.

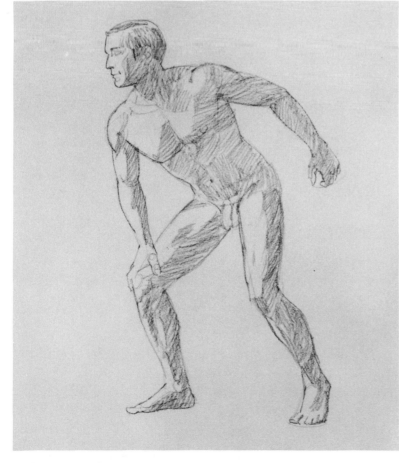

Step 4. The artist sees that the light source is to the left and slightly above the figure. Thus, the left sides of the forms—and some of their tops—catch the light. This is most obvious on the arm that leans on the knee, and on the chest and thighs. The right sides of many of the forms are in shadow, and so are the undersides of the forms that lean away from the light. Thus, the lower part of the torso, from the chest down to the crotch, bends away from the light and is entirely in shadow, as are the free-swinging arm and the lower leg on the right, which bends in the same direction away from the light. By the end of Step 4, the sharp point of the chalk has begun to wear down. Now the artist uses the blunt end of the chalk to block in the shadow shapes with thick parallel strokes. The strokes have a ragged, slightly granular quality that's typical of chalk.

Step 5. Concentrating now on the shadow areas of the figure, the artist builds up the darks with thick, firm strokes, made by using the blunt tip of the stick of chalk. He pays particular attention to the strips of darkness where the light and shadow planes meet. These dark edges are most apparent on the head, chest, thighs, feet, and the straight arm on the lighted side of the figure. The tonal areas begin to show a distinct contrast between the shadows and reflected lights within the shadows. The typically rough texture of the chalk stroke becomes even more obvious as the drawing progresses. The dark, heavy strokes follow the curves of the model's muscles. Toward the end of this step, the artist sharpens the point of the chalk on the sandpaper block once again and begins to strengthen details such as the features, the hand on the knee, and the foot on the left.

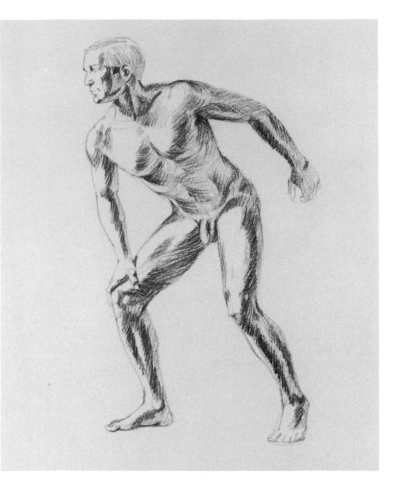

Step 6. Moving carefully around the forms with the sharpened chalk, the artist reinforces all the contours. It's important to notice that some lines are thicker and darker, while others are thinner and paler. He tends to press harder on the chalk, making a heavier line, when a contour comes forward. Conversely, he exerts less pressure on the chalk to make a more delicate line when the contour moves back. Once again, look at the arm that leans on the knee. The bulge at the shoulder moves forward and its contour is drawn with a dark, heavy line. But the muscle beneath is drawn with a lighter line because its contour moves around to the back of the bulging shoulder muscle. In the same way, the protruding bulge of the lower arm is drawn with a darker line than the wrist. Of course, sometimes the artist accentuates a line for a purely expressive reason: the inside of that same arm is drawn with thick lines to give you a sense of weight pressing downward on the knee. Throughout the figure, the artist avoids wiry, mechanical lines, changing the density of the line by altering the pressure on the chalk.

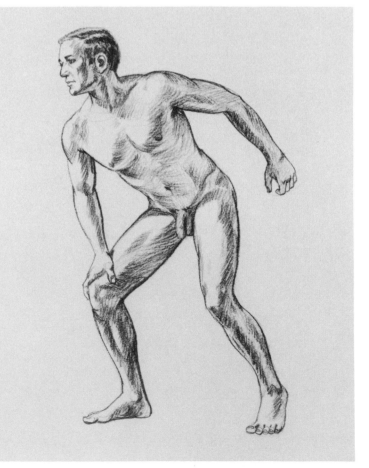

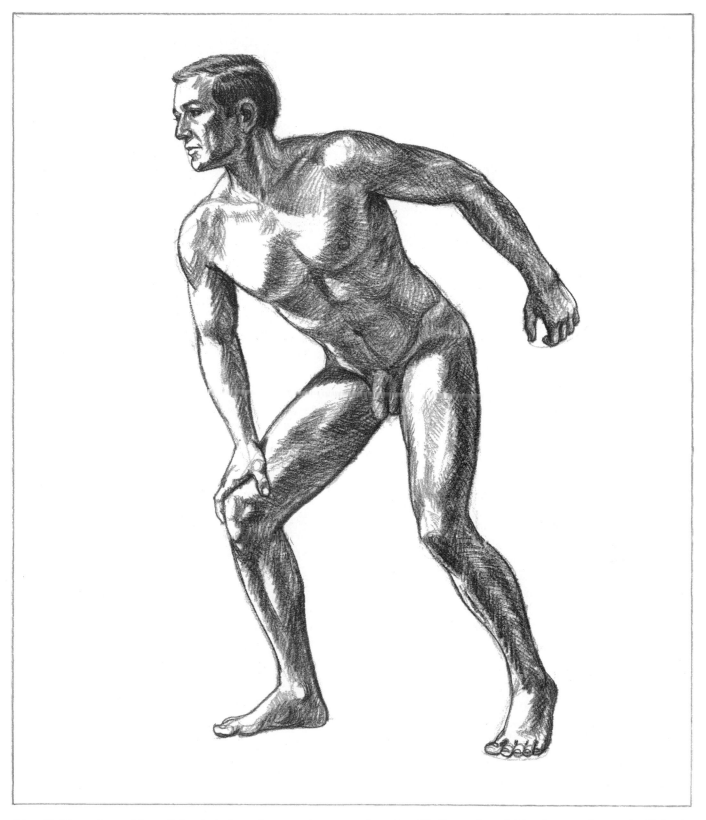

Step 7. The artist enriches all the darks by going over these areas with short, curving strokes that follow the rounded forms. Notice how he builds up the big shadows of the forms that bend away from the light: the lower half of the torso, the arm that swings back, and the lower leg on the right. Within the lighted areas, he builds up the anatomical detail with halftones; a particularly good example of this is the strip of halftone that divides the muscles on the lighted plane of the thigh on the right. When he's completed the halftones, shadow, and reflected lights, the artist sharpens the chalk one last time to accentuate the features, the texture of the hair, and the details of the hands and feet. If a stray smudge of tone finds its way into a lighted area, it's quickly lifted away with a touch of the kneaded rubber eraser.

Step 1. Chalk smudges very easily and can produce wonderful, smoky tones when you blend the strokes with your fingertip or a paper stomp. Now try a drawing in which you combine sharp lines with selectively blended tones. For this demonstration, the artist chooses a sheet of charcoal paper, whose delicately textured surface is particularly good for blending the strokes of the chalk. He chooses two drawing tools: a pastel pencil for the precise line work, and a stick of hard pastel for the broader strokes that will be blended into tones. As always, he starts with a few simple guidelines—and he looks for the most important alignments in the figure. For example, the point of the chin is directly above the vertical thigh and the knee that rests on the floor. The shoulder of the straight arm is directly above the angle where the thigh and the calf meet. The knee of this leg aligns with the underside of the foot at the right. See what other alignments you can discover.

Step 2. As he builds a more complete set of construction lines over the guidelines of Step 1, the artist continues to look for the alignments that are typical of this pose. Notice how the center line of the head curves downward and runs into the curving center line of the torso. The wrist of the straight arm aligns with the underside of the thigh on the right. It's also important to study the shapes of the so-called negative spaces—the gaps between the forms. The artist carefully defines the triangular shape of the space between the straight arm and the waist, as well as the bent triangle of space between the other arm and the outstretched thigh. The negative space between the two legs is also important: it's essentially a rectangle that tapers slightly as the sides move downward to the floor. These negative shapes are part of the figure!

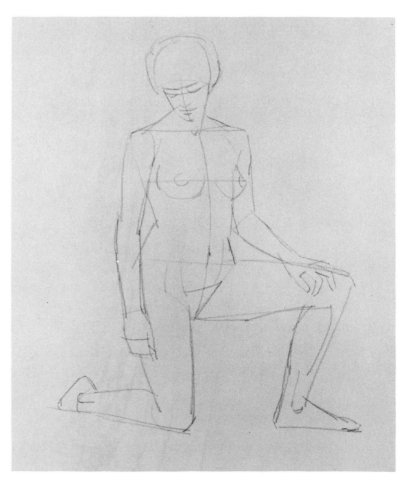

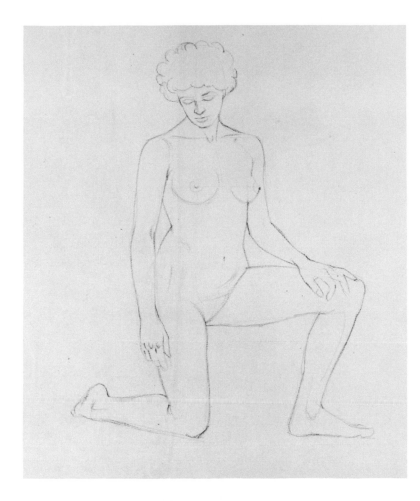

Step 3. Still working with the sharp point of the pastel pencil, the artist draws the contours of the body more realistically and erases the guidelines of Steps 1 and 2. He looks for those places where one contour overlaps another. Notice how the lines of the undersides of the thighs overlap those of the calves. He also looks for those places where one line seems to flow into another. On the right side of the torso, the contour of the chest muscle is interrupted by the breast, but then it seems to continue down over the midriff and hip, ending at the thigh. In the same way, the back of the straight arm flows downward into the back of the thigh, interrupted only by the hand. As your eye travels around the contours of the figure, you can see how the texture of the charcoal paper breaks up and softens the line of the pastel pencil.

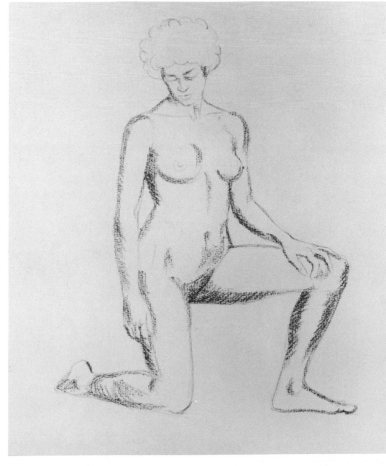

Step 4. The artist puts aside the pastel pencil and picks up the rectangular stick of hard pastel. The squarish end of the stick has been worn down to a blunt shape, and so it makes a thick, soft stroke. The artist studies the direction of the light, which comes from directly in front of the figure. Thus, the fronts of all the shapes are illuminated, while the edges of the shapes are in shadow as they turn away from the light. All the shadows are narrow strips of tone, which the artist indicates by running short parallel strokes around the contours. At this point, the rough texture of the charcoal paper is obvious. All the strokes are broken up by the ribbed surface of the paper. Most of the sharp lines of Step 3 disappear at this stage, but they'll reappear later on.

Step 5. Moving his fingertip gently over the shadow strokes of Step 4, the artist softly blends the chalk marks. He doesn't obliterate the strokes completely, but fuses them into soft, furry tones. Now his fingertip is coated with black chalk, and he uses it like a brush to spread delicate halftones over the lighted areas. In this way, he defines the curves of the shoulder and chest muscles, the side of the rib cage, and the curve along the bottom of the abdomen. The strips of shadow are too slender to show much reflected light. Instead, there's a soft gradation from light to halftone to shadow, which you can see most clearly on the rounded shapes of the breasts and on the cylindrical shapes of the arms and legs.

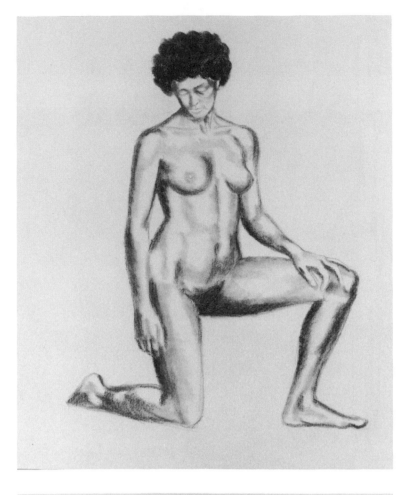

Step 6. Switching back to the pastel pencil, the artist builds up the shadows with parallel strokes that move around all the dark edges of the figure. The strokes look rough and granular because they're broken up by the texture of the charcoal paper. He strengthens the cast shadow beneath the chin. He also adds a cast shadow below the hand that rests on the outstretched thigh. And he begins to define the features more precisely with the sharpened point of the pastel pencil.

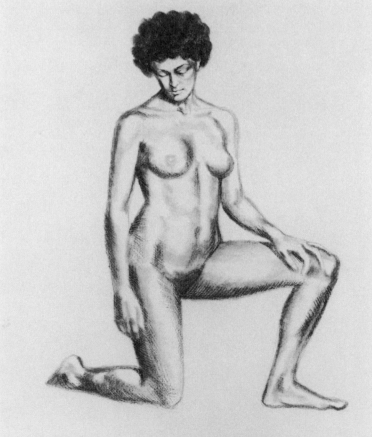

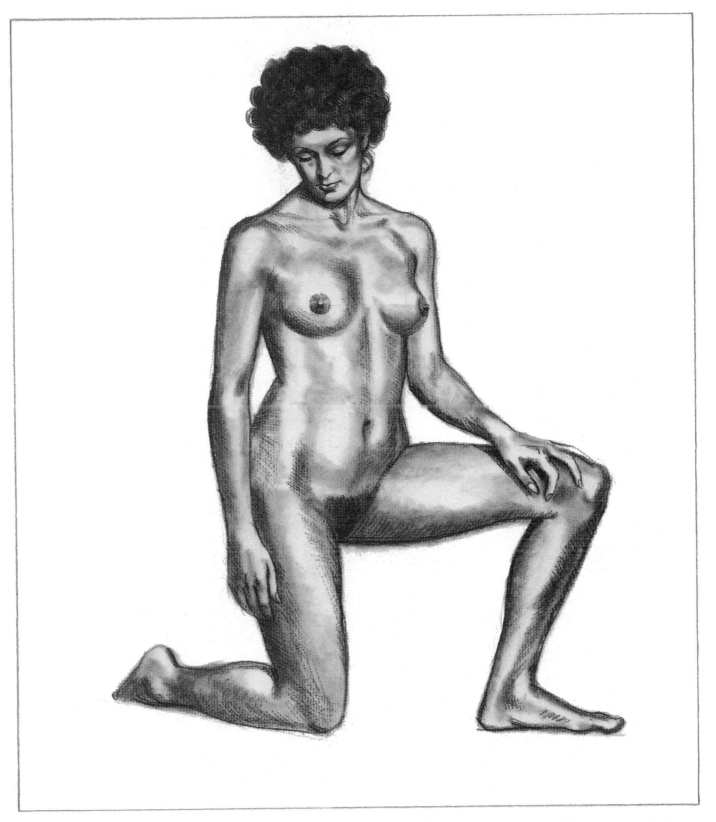

Step 7. The artist runs his fingertip over the edges, blending the narrow clusters of pencil strokes that reinforce the shadows of Step 6. He doesn't blend the strokes totally, but just softens them a bit. The pencil travels around all the edges, redefining the lines that were temporarily lost beneath the blended tones. The rhythmic contours emerge sharply. A fingertip picks up some chalk dust from the sandpaper pad and moves carefully over the halftones within the lighted areas, strengthening these subtle grays to make the skin tones look more luminous. A wad of kneaded rubber is pressed carefully against the lighted areas to remove any hint of gray from the bare paper. Now the skin has a wonderful inner glow. Finally, the sharp pencil point accents the model's curls, features, neck muscles, nipples, navel, hands, and feet.

Step 1. As a change of pace, try drawing a back view. When seen from behind, the female torso is still a pair of blocky shapes that taper to meet at the waist. The shoulders are connected by a horizontal guideline. A vertical center line runs down the spine and curves as the figure bends slightly. The vertical center line locates the center of the neck, travels down the spine, and terminates in the division between the buttocks. The artist places a horizontal guideline at the wide point of the hips. He still visualizes the arms and legs as tapering cylinders. The hand of the straight arm, the buttocks, and one foot all line up firmly on the floor. The heel of the foot on the right aligns with the big toe of the other foot. The chin aligns, more or less, with the edge of the upper torso on the right. One shoulder is a bit higher than the other—and so is one hip—because the model leans slightly to the left.

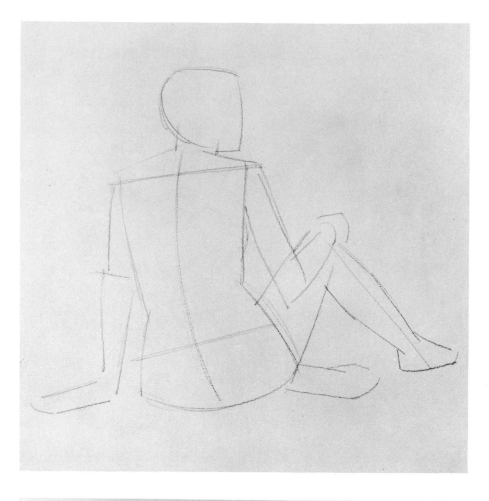

Step 2. Compare the construction lines in this step with the simple "diagram" of Step 1. Now just a few lines divide the shape of the flat hand into fingers. In the same way, a single curving line and a few short lines define the toes of the foot tucked under the buttocks. The other, outstretched foot is seen in perspective, and so it was drawn as a shortened triangle in Step 1; now, with just a few more lines, the artist transforms it into a foot by adding the anklebone and the curve of the toes. In Step 1, the hip on the left was a single curving line; now an extra line squares up the hip and accentuates the bony bulge of the pelvis. The artist places the features carefully over the egg shape of the head and defines the mass of the hair with a few curving strokes. He locates the shoulder blades with two short lines that run downward across the horizontal guidelines between the shoulders. So far, all this linear work is done with a pastel pencil.

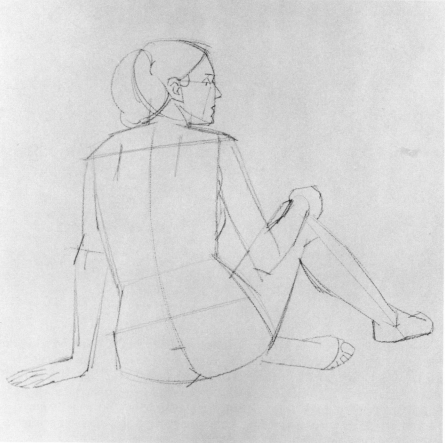

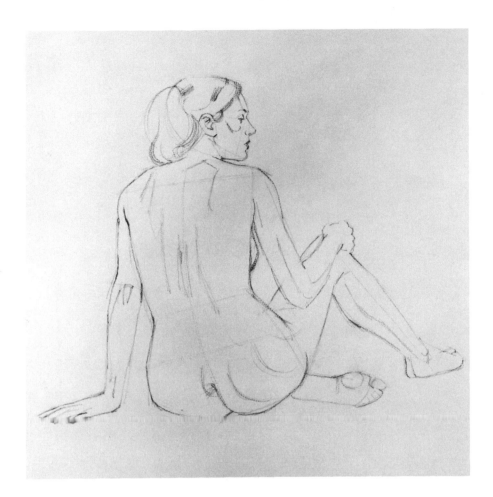

Step 3. The artist moves back over the straight lines of Step 2, gradually replacing them with flowing, rhythmic ones. He looks for contours that flow into one another. One continuous line—with subtle changes in direction—travels from the wrist on the left all the way up the arm and across the shoulder, terminating at the back of the neck. In the same way, the contours of the left side of the torso merge into a single line that flows from the armpit over the back and hip, finally swinging around to end at the division of the buttocks. The curve of the other buttock swings upward counterclockwise, disappearing momentarily at the thigh and then reappearing at the hip and running along the side of the torso up to the armpit. On the arm and leg at the right, as well as on the back, you begin to see lines that indicate the edges of the shadow shapes.

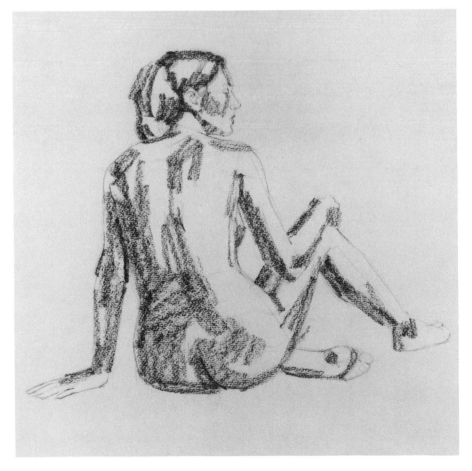

Step 4. This demonstration will show you how to make a drawing almost entirely of blended tones. The artist blocks in the tones with the square end of a stick of hard pastel, which makes broad, rather rectangular strokes. Just a few strokes cover a great deal of territory. The light comes from the right, and so the left sides of the forms are in shadow. Because the torso blocks the light, the arm on the left is totally in shadow; only a bit of the hand protrudes into the light. The spine curves away from the light, and so a slender shadow runs down the important center line. The edges of the shoulder blades also curve away from the light; the artist indicates the slender shadow on each shoulder blade with a single stroke. Study the touches of shadow on the smaller forms: the hollow of the cheek, the underside of the foot, and beneath the anklebone of the other foot.

Step 5. The artist picks up a large stomp and holds it at an angle to the paper. Thus, he works with the slanted side, rather than with its pointed tip. With vigorous strokes, he sweeps the stomp back and forth over the irregular drawing surface, blending the strokes that appeared in Step 4. These strokes quickly become dark, velvety tones as the granular chalk marks are blurred by the stomp. To blend smaller areas—particularly on the face, hands, and feet—the artist uses the sharp point of the stomp. Then, when the stomp is coated with chalk dust, he uses the cylindrical tool like a brush to add touches of halftone within the lighted areas of the figure. You can see these halftones around the shoulder blades and along the edge of the shadow that travels down the spine. He also adds a hint of halftone along the lighted edge of the leg and foot at the right.

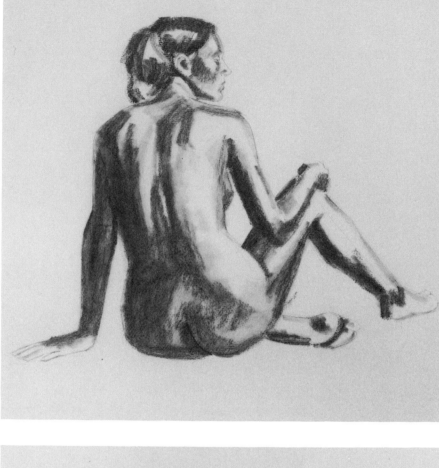

Step 6. With a fingertip, the artist blends the rough tones of Step 5 more smoothly, producing more delicate gradations. The effect is obvious along the edges of the shadows, which now merge more softly with the lighted planes. He moves back into the shadows with a kneaded rubber eraser to create reflected lights. He squeezes the eraser to a rounded tip and presses it very gently against the shadow areas, lifting off small quantities of chalk. Then he goes over these areas with his finger to blend them once again. Now there are luminous reflected lights within the big shadow shapes of the back and the slender shadow shapes on the arms and legs. Squeezing the kneaded rubber to a sharp point, he picks out smaller areas of light, such as the elbow of the arm at the left and the bones of the spine. And he begins to reinforce selected darks with the chalk—in the hair, within the ear, beneath the chin, on the left arm, and along the outstretched leg.

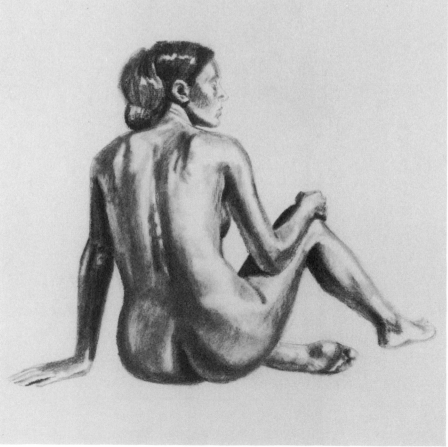

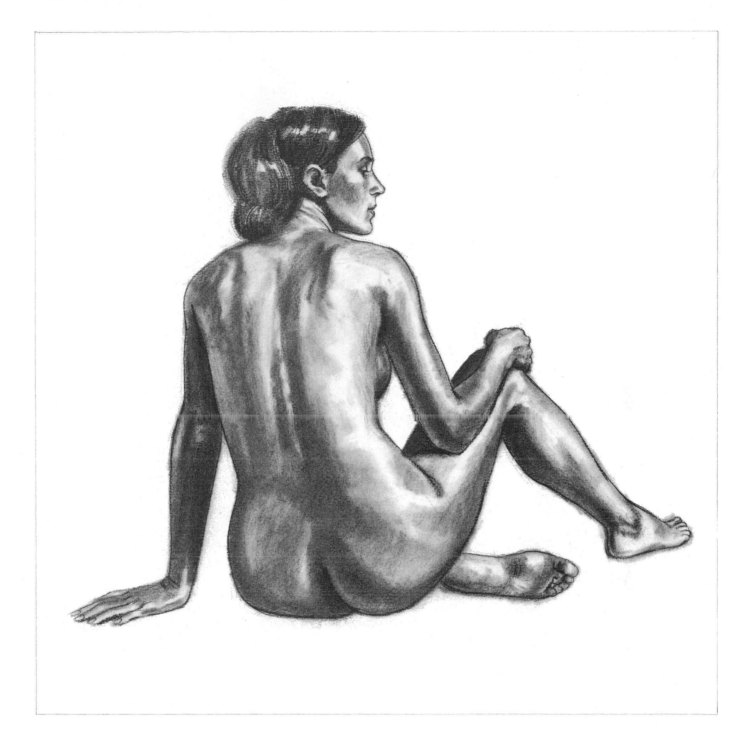

Step 7. In the process of blending, the original contours tend to disappear. The artist restates them now with the sharpened pastel pencil. He redefines the profile and features and adds some lines to the hair. For the last time, his fingertip travels gently over the shadows, blending them more smoothly and carrying a few more halftones into the lighted areas—particularly the lighted planes to the right of the spine—and on the outstretched leg. He squeezes a kneaded rubber eraser to a point to brighten these lighted areas; now the completed drawing has a strong contrast between the lights and shadows. To heighten the impact of the dark figure against the white paper, the kneaded rubber moves around the outer edges of the figure, eliminating any stray tones that might soil the clean surface of the sheet.

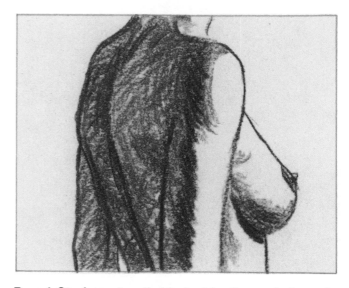

Slender Strokes. Hard and medium charcoal pencils can be sharpened to a point to draw the contours of the figure with slim lines like those you see around the outer edges. With the point or the side of the lead, you can also build up tones with clusters of parallel lines like those you see in the shadow areas of the model's back and arms. Tones can be darkened by building one layer of strokes over another and pressing harder on the pencil, as in the shadow under the breast.

Broad Strokes. A cylindrical stick of natural charcoal, the thick lead of a soft charcoal pencil, and a thick charcoal lead in a holder will each make rough, broad strokes. Here, the same female torso is drawn with a soft charcoal pencil. Even when the pencil is sharpened, it has a slightly blunt tip that outlines the figure with a thick, slightly broken line. To render the tones, the pencil is held at an angle to make broad strokes. The shadow areas are quickly covered with a few sweeps of the thick lead.

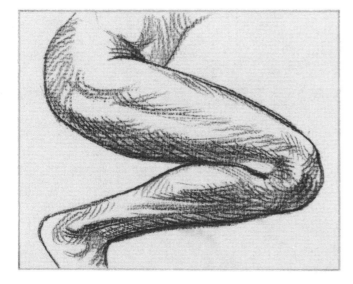

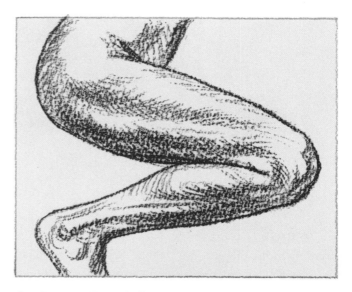

Strokes on Charcoal Paper. As the name suggests, charcoal paper is made specifically for this drawing medium. This leg is drawn with a sharpened medium charcoal pencil. Where the pencil glides lightly over the paper— as in the buttock—the texture of the sheet breaks up the stroke into flecks of black and white to suggest luminous halftones. Where the pencil presses harder against the paper—as in the outlines and the shadows—the stroke still has a lively, irregular quality. All the tones are penetrated by pinpoints of bare paper, which make the halftones and shadows look transparent.

Strokes on Rough Paper. The strokes of the charcoal pencil—or the charcoal stick—become *more* pebbly and irregular on a rougher sheet. The tooth of the paper tends to break up the stroke into a granular pattern of dark flecks. The outlines of this leg have a ragged quality, while the tones look like a pattern of dark granules, showing very few distinct strokes. A charcoal drawing on rough paper can't be as precise as a drawing on a smoother sheet, but it *does* have a special boldness and power.

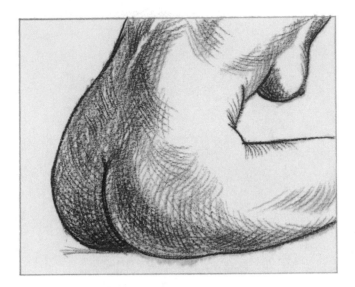

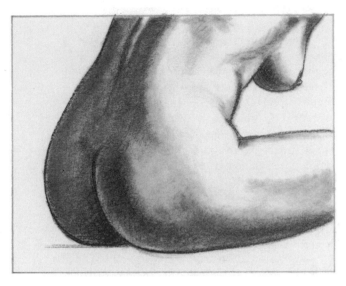

Modeling with Strokes. Charcoal is particularly effective for creating subtle gradations of tone. One way to do this is to gradually build up clusters of curving strokes that "mix" in the viewer's eye to become tones. A series of parallel strokes with slender spaces between them can suggest a halftone like the soft gray area on the side of the buttock or along the thigh. A second or third layer of strokes, placed close together, will produce a darker tone like the shadowy curve of that same buttock or the underside of the thigh.

Modeling by Blending. If you move your fingertip over the strokes you see at your left, they gradually disappear, fusing into smoky tones. For this blending technique, it's best to work with a medium or soft charcoal pencil, or with a stick of natural charcoal. To build up the dark contours along the undersides of the buttocks and breasts, the artist piles on more strokes and blends them with his fingertip. To create the halftones on the side of the buttocks and thigh, he just touches the paper with a few light strokes and blends them with a fingertip.

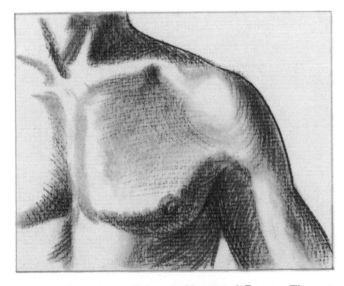

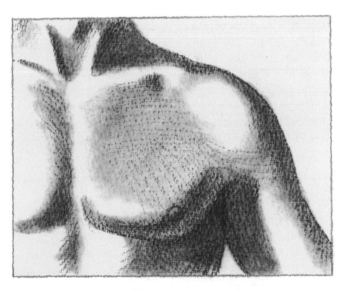

Strokes and Blending on Charcoal Paper. The outline of the shoulder is drawn with the sharp point of a medium charcoal pencil. The side of the lead blocks in the tones with broad strokes, blended by a fingertip. The pencil goes over these blended areas with parallel strokes that strengthen the shadows and accentuate the forms. You can see these blended tones, heightened with pencil strokes, along the shadowy edges of the arm and chest muscles. The strong darks along the neck and beneath the armpit are clusters of firm, unblended strokes.

Strokes and Blending on Rough Paper. Here's the same technique on a rougher sheet. Again, the artist draws the outlines with a medium charcoal pencil and then blocks in the tones with the side of the lead. He blends the tones with a stomp and reinforces the darks with the pencil. Thus, the darks along the side of the neck and shoulder, as well as those surrounding the armpit, have a particularly deep, powerful tone. The subtle halftone on the chest muscle is a soft blur, which the artist darkens slightly by letting his pencil glide lightly over the paper.

Step 1. Charcoal blends so easily that it's tempting to smudge every stroke to produce those wonderful, velvety tones, but it's best to begin by exploring what you can do with unblended lines and strokes. Try drawing some figures in which you render the contours with slender lines, made with the sharpened tip of the charcoal pencil, and render the tones with broad strokes by using the side of the lead. An action pose can be hard to draw, but the job becomes a lot easier if you plan the preliminary "diagram" carefully. The key to the pose is the curving center line that moves downward from the neck through the chest and navel to the crotch. Reflecting the curve of the center line, the edge of the torso at the right moves in the same direction—from the armpit all the way down to the knee. The inner line of that same thigh repeats the curve of the center line. The edge of the outstretched lower leg doesn't *curve* in the same direction, but it's roughly parallel with the side of the body. The lines of the upper arms all travel in the same direction.

Step 2. The artist begins to build up the anatomical forms. He draws the bulges of the shoulders over the connecting guideline and then defines the square shapes of the chest muscles that connect with the shoulders. On the abdomen, he indicates the lines of the stomach muscles on either side of the navel. He suggests the rounded form of the knee with a curving line. He accentuates the triangular shapes of the feet. Notice how the fists are divided into two halves to represent the palms and the group of clenched fingers. Finally, he adds more lines to stress the alignment of the jaw, neck muscle, pit of the neck, breastbone (where the chest muscles meet), navel, and crotch along the curving center line. This center line will continue to be the key to the action.

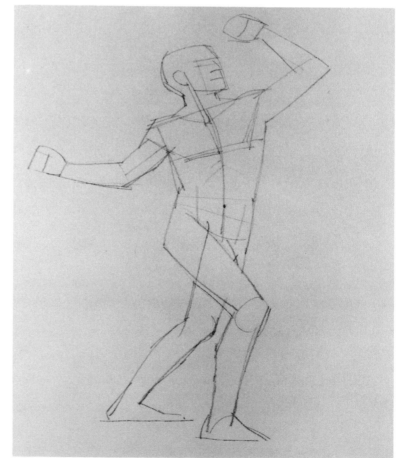

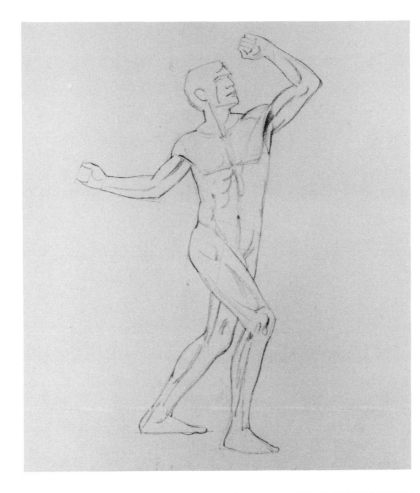

Step 3. The artist looks for the internal rhythms of the contours when he transforms the rigid lines of Step 2 into curving, springy lines. The edge of the torso on the right is a single contour that moves from the armpit down to the knee, interrupted only by the opposite thigh. The top of the protruding thigh curves around the egg-shaped hip muscle and then runs upward along the left side of the torso to the armpit. There are also some less obvious connections that lend rhythm to the pose. For example, look at the line of the underside of the outstretched arm at the left: this line swings upward to the armpit, disappears behind the chest muscles, and then reappears in the curve of the opposite shoulder.

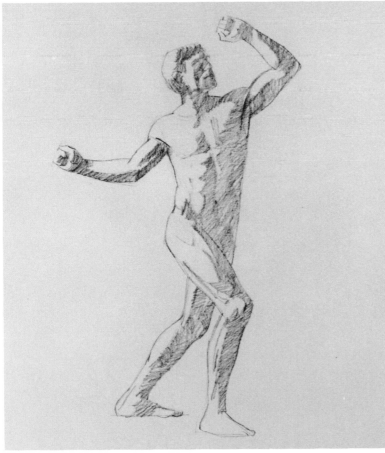

Step 4. The artist sees that the light comes from the left and from slightly above the figure. Thus, the left sides of the forms catch the light and the right sides turn away into darkness; you can see this most clearly on the torso, the lower legs, and the forearm that's raised above the head. The light also touches the tops of some forms and throws the undersides into shadow— as in the outstretched arm on the left and the upper arm on the right. So far, the artist has been working with the sharpened point of a medium charcoal pencil. Now he blocks in the shadows with broad strokes, using the side of the lead. Even as he blocks in the shadows, the artist preserves the curving center line of the torso, which is so important to the movement of the figure. Notice how the shadow of the corner at the jaw, the edge of the shadow at the neck, the strip of light between the chest muscles, and the stomach muscles all follow this center line. If you continue to move your eye downward, this center line reappears as the edge of shadow on the leg that moves backward behind the figure.

Step 5. Pressing harder on the side of the lead of the medium charcoal pencil, the artist darkens the edges of the shadows where they meet the lighted planes of the figure. Suddenly, the figure grows more luminous as each shadow contains two tones: the dark and the reflected light. The artist works with bold, curving strokes, moving rapidly down the form. Sometimes the *shadow accent* (as the dark edge of the shadow is often called) is a single, thick, curving stroke, like those on the abdominal muscles. At other times, it's a series of short strokes placed side by side, as you can see on the up-raised arm, the thighs, and the lower legs. The artist keeps focusing attention on that all-important center line, which he darkens with a series of strokes that start at the neck muscle, move down between the chest muscles and between the abdominal muscles, and then continue along the edge of the shadow on the rear leg.

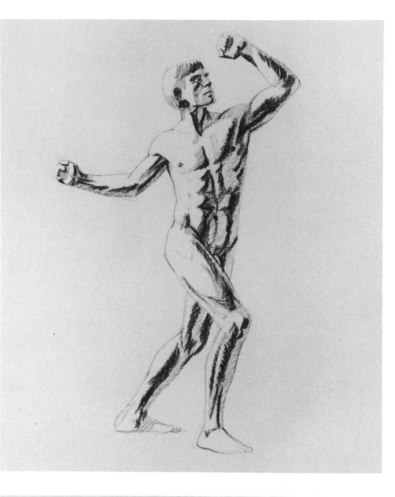

Step 6. The sharpened tip of the charcoal pencil now moves around the contours of the figure, redefining the outlines. The artist pays particular attention to those places where one contour overlaps another, such as the shoulders, the biceps, and the inside corners of the elbows. These overlapping contours suggest that one form moves forward while another form moves behind it; thus, the body looks more solid and three-dimensional. The point of the pencil also begins to accentuate the details of the face, fingers, and toes. This is one of those drawings in which the artist could easily stop at this point: although not every part of the drawing is finished, there's just enough detail and just enough tone to make a lively, powerful drawing. But he goes on to Step 7 to show you the full range of tone that's possible with a medium-grade charcoal pencil.

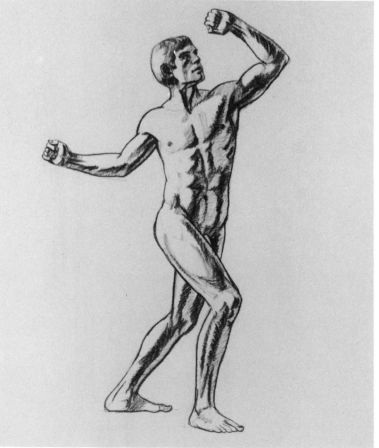

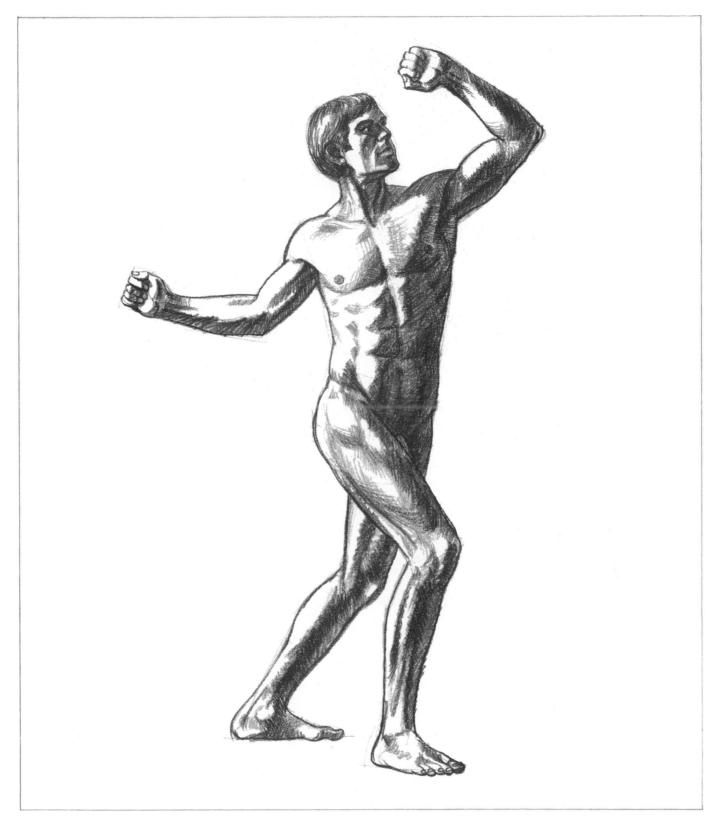

Step 7. With short, closely packed parallel strokes, the artist deepens all the shadows. Now there's a powerful contrast between the lighted and shadow sides of all the forms. The figure not only looks more solid, but the stronger shadows accentuate the inner rhythms of the figure. The dark strip of shadow dramatizes the curve of the outstretched arm, for example, while the center line of the torso stands out more dramatically because of the contrast of light and shadow. Within the lighted areas of the figure, the artist develops halftones that define the anatomical details more clearly; look at the muscles of the thigh. Finally, the sharp point of the pencil heightens such details as the hair, features, fingers, nipples, anklebones, and toes.

Step 1. Try a combination of lines for the contours, plus strokes and selective blending for the tones. The artist works with hard and medium charcoal pencils, plus a natural charcoal stick, on a sheet of rough paper. The hard charcoal pencil executes an extremely simplified "diagram" of this action pose. To draw a dynamic pose like this crouching male figure, the most important thing is to record the directions of the lines accurately. It's often best to begin with the line of the back—a steep slant in this pose. The lines of the forward leg are almost horizontal and vertical, but not quite. Because the figure leans forward, the line of the shoulders is also slanted. In the leg that reaches back, we see only a bit of the thigh—which is in perspective—but we see most of the lower leg.

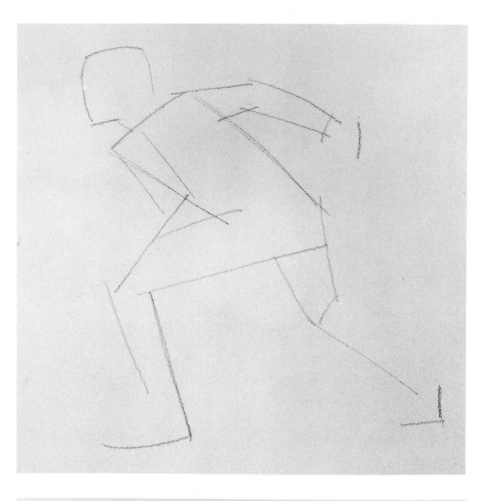

Step 2. As the artist builds up the construction lines of the figure, we see the shapes of the body more clearly, though they're still highly simplified. As always, the artist looks for alignments. The wrist of the upraised arm is directly above the line of the buttock and thigh. The chin is above the outstretched knee. The slanted line along the underside of the outstretched lower leg is parallel to the sloping line that runs along the underside of the torso; this torso line points to the tip of the chin. The top of the outstretched arm is parallel to the thigh of the outstretched leg. All the major lines of the figure are slanted, though some are steeper than others.

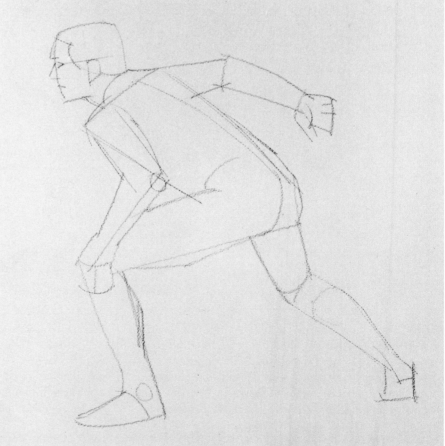

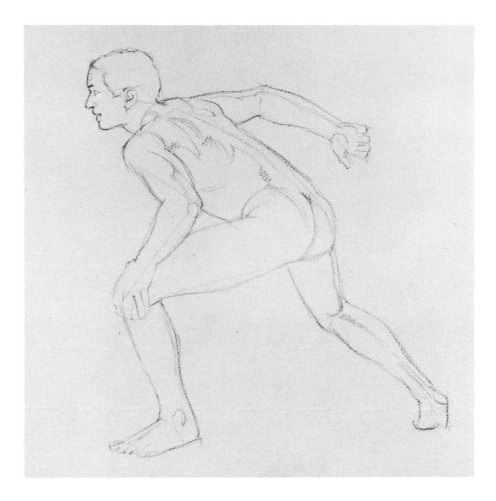

Step 3. The point of the hard charcoal pencil curves around the shapes of the body, recording the anatomical forms and searching for rhythmic connections between lines. For example, the underside of the outstretched thigh is represented by a line that divides into two lines at the buttocks: one line curves around at the division between the buttocks and travels upward to become the spine, terminating at the back of the neck. The other line continues around the far buttock and travels along the far side of the back, flowing into the shoulder. Such big, flowing lines give the figure a feeling of dynamic rhythm.

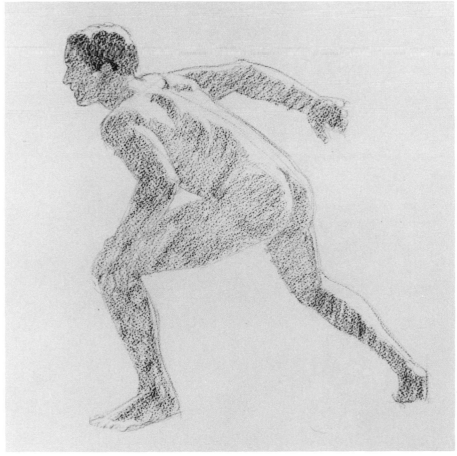

Step 4. The light source is on the right, above and behind the figure. This creates an effect that's often called *rim lighting*. Most of the figure is in shadow, with just a bit of light creeping around the *rims* of the forms. With a stick of charcoal, the artist blocks in the big shapes of the shadows, letting the stick glide lightly over the roughly textured paper. The charcoal hits the high points of the pebbly surface; the tones become broken and granular, obliterating many of the lines of Step 3. Of course, these lines will reappear later on. The artist studies the shapes of the shadows carefully, paying particular attention to the zigzag shadow on the back, and the jagged shapes of the shadows on the shoulders.

Step 5. A fingertip moves lightly over the granular tones of Step 4, softly fusing them into smoky shadows. The artist blends the smaller shapes—the profile of the face, the protruding finger, and the back muscles—with the tip of a stomp. Where the shape of a shadow needs to be defined more carefully, the artist squeezes the kneaded rubber eraser to a sharp point and moves the soft rubber around the edge. He does this on the intricate shadow shapes on the shoulders and he also brightens the back of the arm that rests on the knee. When you blend the tones of natural charcoal, it's important not to press too hard against the paper or you'll wipe off the charcoal, rather than simply spreading it around.

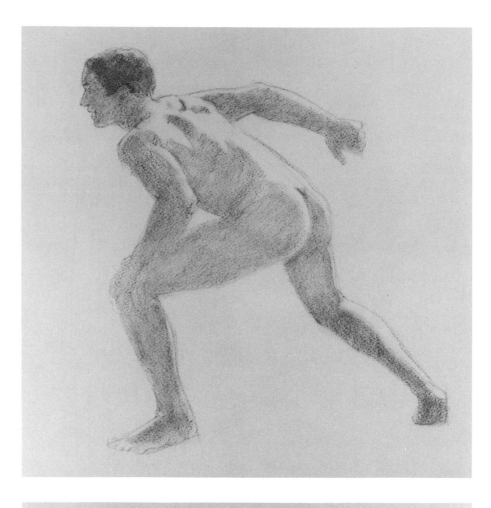

Step 6. The artist redefines the contours of the figure with sharp lines made by the point of a medium charcoal pencil. As he records the anatomical forms of the living model, he looks for those overlapping contours that make the muscles round and solid: the curve of the buttock overlaps the outstretched thigh, for example. These overlaps aren't always predictable; they vary from one pose to another. You can't just make them up—you've got to see them on the model! With the side of the lead, the artist builds up the edges of the shadows where they meet the lighted planes of the body. Now each shadow area contains darks and reflected lights. The point of the pencil also begins to define the details of the features, hands, and feet.

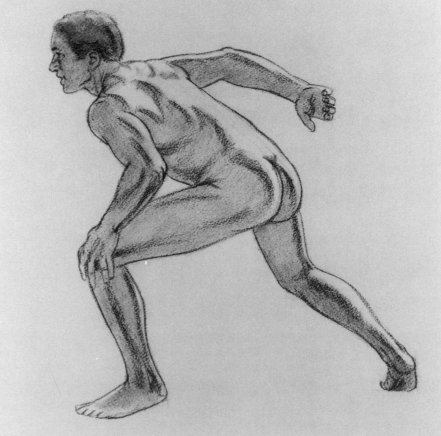

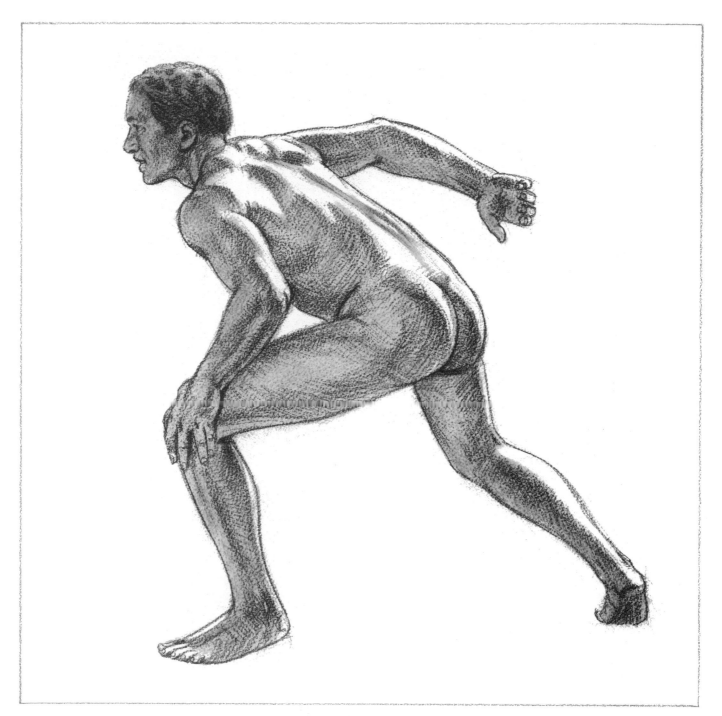

Step 7. Moving the side of the medium charcoal pencil lightly back and forth over the smoky shadows, the artist gradually strengthens and unifies the dark planes. He also defines the edges of the shadows more precisely. He doesn't blend these strokes, but allows them to retain the granular texture of the rough paper. As the shadow areas become darker, the figure becomes more three-dimensional because of the stronger contrast between light and shadow. You may have noticed that the line of the spine has gradually disappeared; the tilt of the spine is important to the action of the figure, and so now the artist redraws the slender, shadowy trough at the center of the back and carefully blends the tone

with the sharp tip of the stomp. The point of the pencil also adds sharp touches of darkness in small but critical areas such as the underside of the nose, ear, and chin; the underside of the hand that rests on the knee; the crease at the waist; and the underside of the buttock above the outstretched rear leg. These crisp blacks add sparkle to the drawing. Finally, the tip of the pencil completes the details of the features, hands, and feet. A few more touches of the kneaded rubber eraser brighten the lighted areas of the body and clean away any smudges of gray that may have strayed onto the white paper surrounding the figure.

Step 1. At first glance, a reclining figure looks difficult to draw because all the normal relationships between the parts of the body seem to be askew. But the essential problems are the same: you've just got to get the proportions, alignments, and directions of the lines right. In this pose, the underside of the arm on the floor flows into the underside of the adjacent leg. The torso still consists of two interlocking, blocky forms with the usual guidelines. Because the torso curves slightly, the center line also curves a bit, while the guidelines across the body tilt a little more than usual. The lower torso presses against the floor, and so one hip rises into the air.

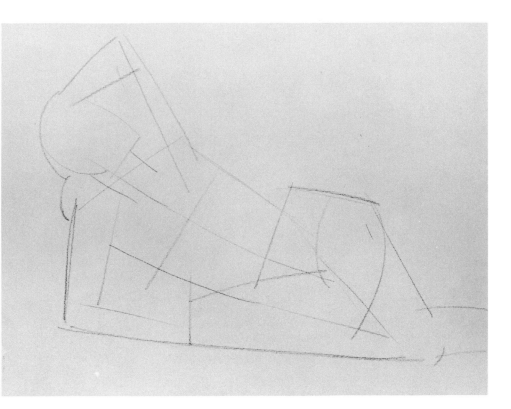

Step 2. As the artist constructs the simplified forms of the body, he discovers other relationships that are helpful in visualizing the figure. On the side of the torso closest to the floor, the line of the upper torso flows into the inner line of the calf. On the other side of the body, the line of the torso curves into the line that defines the inside of the thigh. The shoulders tilt because the weight is on one arm, but the breasts, navel, and crotch are still in their usual places along the center line of the torso.

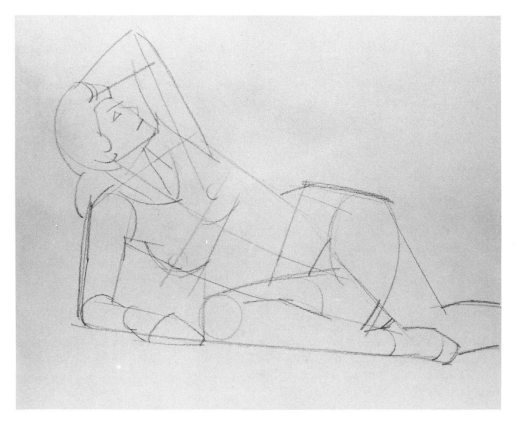

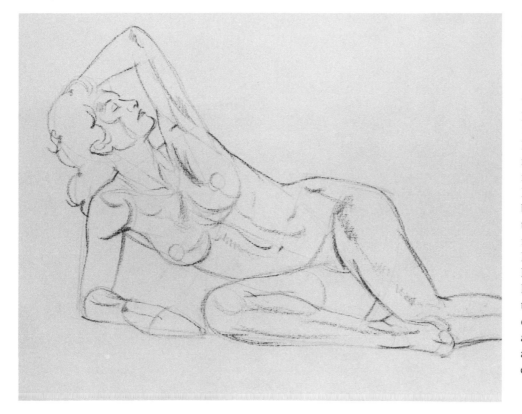

Step 3. The purpose of this demonstration is to show you how to combine linear contours with blended tones for the shadows. The artist has chosen a sheet of charcoal paper and started work with a medium charcoal pencil. Now he switches to a stick of natural charcoal that makes a rougher, more irregular line. He redraws the contours with big, swinging arm motions that give a particular roundness to the forms and a lovely, loose quality to the lines. Notice how a single flowing line moves from the point of the upraised elbow all the way down to the angle of the knee at the lower right. The artist also begins to suggest the edges of the shadows.

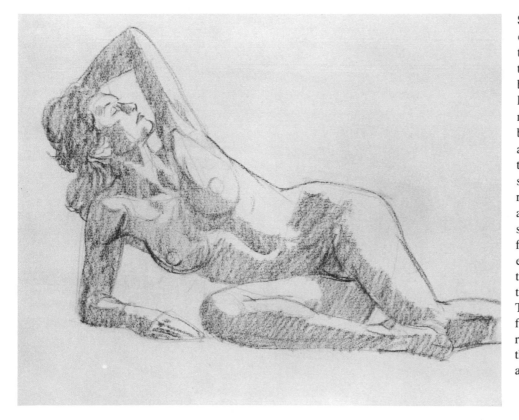

Step 4. Holding the natural charcoal at an angle and letting it brush lightly over the textured surface, the artist blocks in the shadows with loose back-and-forth movements, producing clusters of broad parallel strokes. The artist pays particular attention to the curving shapes of the shadows that accentuate the rhythm of the figure. For example, a single strip of shadow curves downward from the point of the raised elbow, over the arm, around the breast, and down through the center line of the torso. The light source is above the figure and slightly to the right, and so the left sides of the forms and their undersides are in shadow.

Step 5. The strokes that fill the shadow areas are blended with light touches of a fingertip. The artist rubs just hard enough to merge the charcoal strokes into smoky tones, but *not* hard enough to obliterate the roughness of the strokes entirely. He moves his fingertip cautiously around the lighted areas to avoid any danger of obscuring the shapes of the lights. He uses his charcoal-coated fingertip to place a delicate touch of halftone on the lighted side of the midriff, suggesting the details of the ribs, which stand out in this pose. The original outlines are beginning to disappear beneath the blended tones. They'll soon reappear.

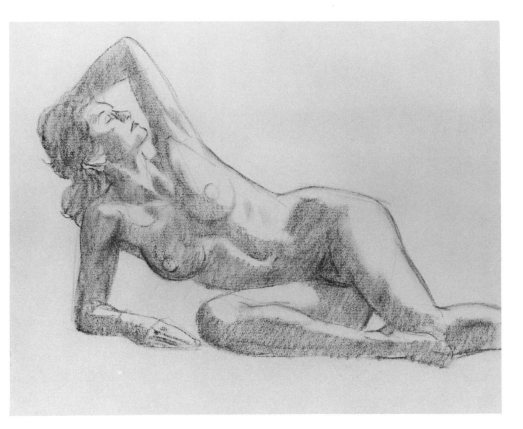

Step 6. Again holding the stick of natural charcoal at an angle to the paper, the artist builds up the dark edges of the shadows—the shadow accents—where they meet the light. Then he blends these darkened edges with his fingertip, being careful not to spread darkness into the paler areas of the shadows, which are the important reflected lights. Now there are three distinct tones flowing together—light, shadow, and reflected light—which you can see most clearly on the breasts beneath the upraised arm. The artist sharpens the charcoal stick to suggest the details of the sitter's curls and the shadows between the fingers.

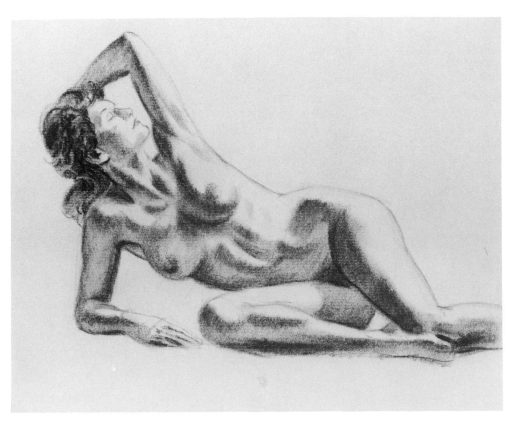

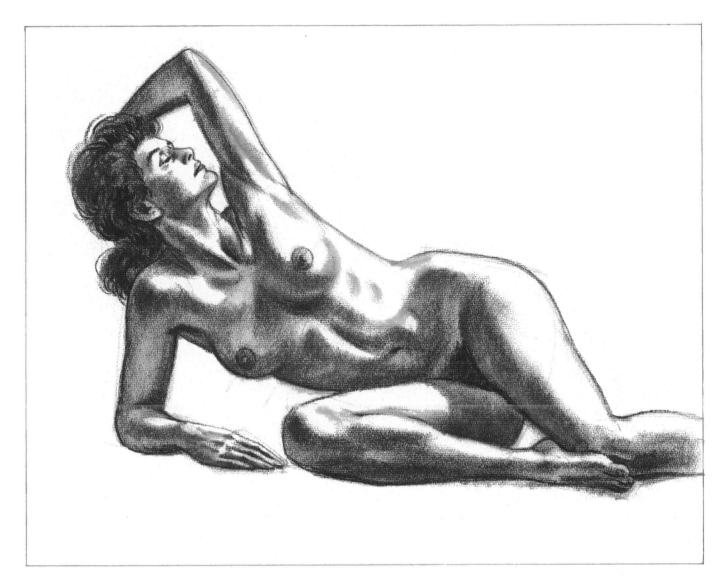

Step 7. A lot of contours have disappeared or just become indistinct as the artist blended the tones with his finger. Now he sharpens the stick of charcoal on the sandpaper pad—not pressing too hard, in order to avoid breaking the fragile stick—and carefully redraws the lines that surround the forms. He rests the charcoal stick lightly against the paper and pulls the tool along without exerting too much pressure, following the contours accurately, but lettting the lines simply "happen." Thus, the lines have a springy, casual quality. Notice that the lines are thicker and darker along the shadow sides of the forms, thinner and paler along the lighter sides. The artist darkens selected spots—such as the upraised forearm and the abdomen—by gradually adding more strokes and blending them with a fingertip. Other areas—such as the outstretched thigh—are lightened with gentle touches of the kneaded rubber eraser, followed by gentle blending with the fingertip. As the artist blends the dark edges of the shadows, delicate halftones appear between the light and shadow planes. The blackened fingertip also adds halftones to suggest additional detail within the lighted side of the upraised arm, alongside the chest muscle, and beneath the breast. To add the last sharp details of the features and hair, the artist switches back to the medium charcoal pencil. The kneaded rubber eraser brightens the lighted areas of the figure and cleans the bare paper that surrounds the forms.

Step 1. In this final demonstration, the artist shows you the full richness of blended tones that you can achieve with a complete "palette" of charcoal pencils, blended with the finger and stomp, and brightened with that miraculous kneaded rubber eraser. As you'll see in a moment, he chooses a figure that's in deep shadow, with just a few touches of bright light; within these deep shadows, there will be rich variations of tone. The preliminary "diagram" of the figure is drawn with the sharpened point of a hard charcoal pencil. There are very few guidelines now—they should really be in your head.

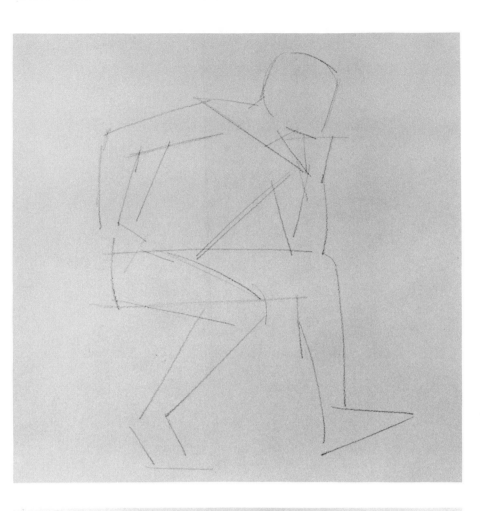

Step 2. The sharp point of the hard charcoal pencil completes the construction lines. Now you can see the alignments more clearly. The forward edge of the leaning torso runs parallel with the forward edge of the lower leg at the left; both are diagonals. The inner edge of the other calf runs upward into the inner edge of the arm that rests on the knee. Both elbows align with the undersides of the chest muscles. On the right, the forehead, nose, fist, and forearm all align with the forward edge of the lower leg. At the left, the inner edge of the forearm continues down into the buttocks, whose curving line points toward the heel. As you study the drawing, you'll discover still other alignments like these.

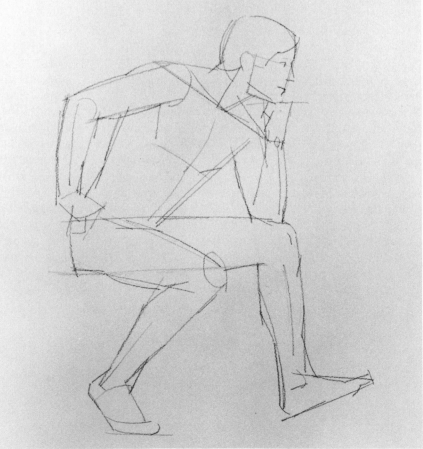

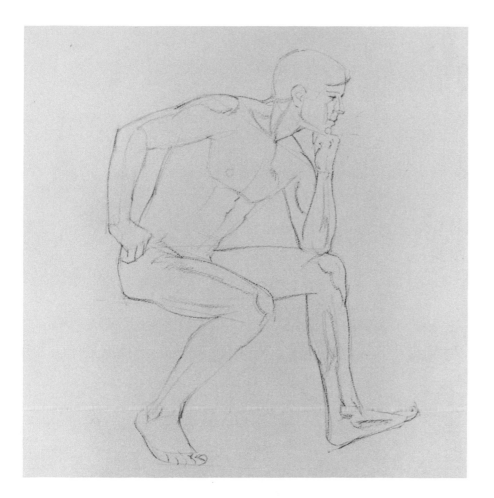

Step 3. The realistic contours are redrawn with the hard charcoal pencil. Notice the line that starts at the point of the elbow on the left, flowing upward over the back of the arm, into the shoulder, and then continuing behind the neck over the opposite shoulder. The back of the lower leg on the left flows diagonally upward, disappears briefly at the knee, and then reappears as the line along the underside of the thigh at the right. The small patches of light are particularly important in this shadowy figure. You can see their outlines along the top of the upraised shoulder, on the opposite shoulder and chest, along the edges of the arm and lower leg at the right, along the top of the other thigh, and on the front of the head.

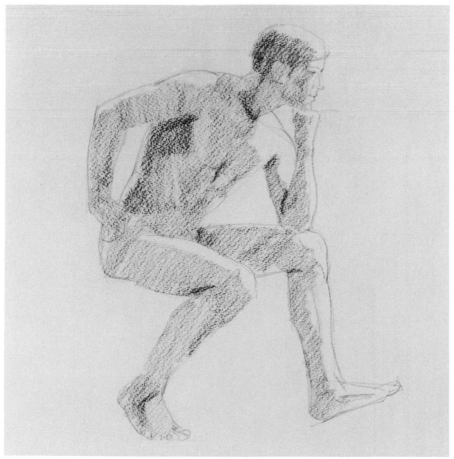

Step 4. Switching to a medium charcoal pencil, the artist flattens the side of the lead by rubbing it against the sandpaper pad. Then he blocks in the shadows with broad parallel strokes. The medium charcoal pencil is softer and darker than the hard pencil, and the pebbly tooth of the paper shaves off big granules. At this stage, the shadows have a ragged, broken texture. To accentuate the shadows along the left side of the torso, the dark tone of the hair, and the other touches of darkness at the pit of the neck, between the chest muscles, and at the joints, the artist presses the pencil more firmly against the paper, building heavier strokes over the original strokes. Notice how methodically the artist follows the shapes of the shadows that are defined by the line of Step 3.

Step 5. The artist blends the strokes of Step 4 with back-and-forth movements of his fingertip. He presses just hard enough to spread the tones without obliterating the rough texture of the original strokes. Thus, the shadows retain the texture of the rough paper. Notice how the dark patch along the back of the torso blends softly into the lighter shadow area. With his charcoal-coated fingertip, the artist adds a halftone along the inner edge of the muscle of the calf at the right. To blend the areas that need a more precise touch—such as the darks in the facial features and in the joints—the artist uses the tip of a stomp. He carefully maneuvers the fingertip and the stomp around the lighted areas.

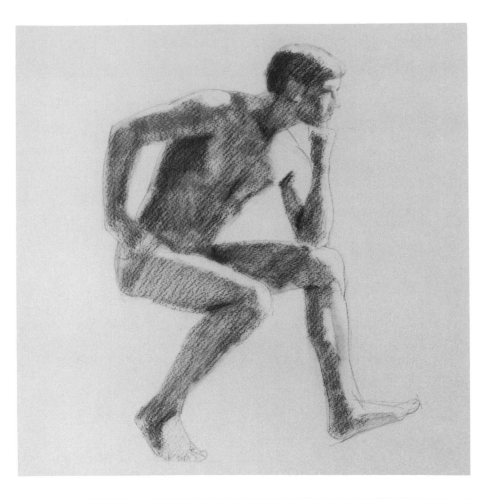

Step 6. A dramatic change takes place in the shadows when the artist switches from the medium charcoal pencils to the thick black lead of the soft charcoal pencils. This new drawing tool moves along the edges of the shadows—where they meet the light—and then the artist blends these dark edges carefully with his fingertip, cautiously avoiding those precious strips of light. Then the soft pencil moves into the shadow areas to add such anatomical details as the abdominal, arm, and leg muscles. Touches of darkness are deftly added to the features, hands, feet, and the knee beneath the elbow. The stomp blends these deep blacks. Now the figure begins to develop the full richness of tone that only charcoal can achieve.

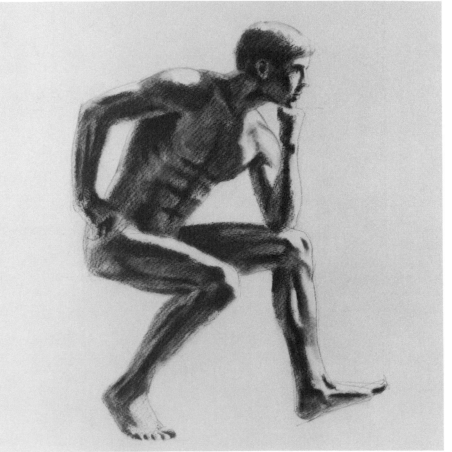

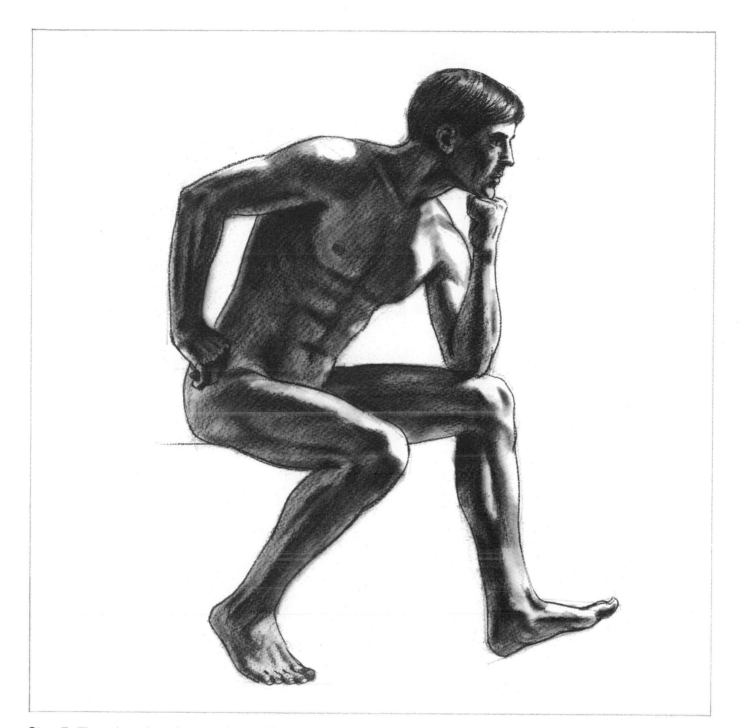

Step 7. The artist refines the tones by working alternately with the soft charcoal pencil, his fingertip, the stomp, and the kneaded rubber eraser. The fingertip travels gently over all the shadow areas, blending and softening the tones so that they flow together more smoothly. As the fingertip continues to blend the shadows, they grow slightly lighter. The soft pencil darkens the edges where necessary. The stomp blends such small tonal areas as the features, hands, and feet. The pencil defines the shadowy edges of the chest muscles more precisely and these are blended with the tip of the stomp. The blackened stomp also strokes in the half-tones in the lighter areas of the arm that leans on the knee. The kneaded rubber eraser gently lifts a hint of tone from the reflected lights within the shadows. Then the eraser brightens the patches of light that contrast brilliantly with the surrounding darks. The medium charcoal pencil redraws the contours, adds lines to the dark blur of the hair, defines the features more exactly, and finishes the hands and feet. Blended tones always tend to creep out over the white paper. Squeezing the kneaded rubber eraser to a sharp point, the artist moves the eraser gently around the outer edges of the figure to restore the brightness of the white paper. Notice how the kneaded rubber eraser also picks out a few touches of light on the abdomen, along the edge of the arm at the left, and at the heels.

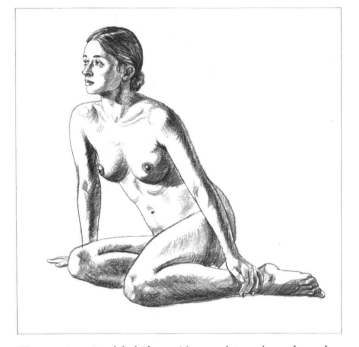

Three-quarter Lighting. Always determine where the light is coming from. This is a familiar type of lighting in which the light comes from the side and from slightly in front of the figure, as if the sun were shining over your left shoulder. The left sides and the fronts of forms catch the light; the right edges are in shadow.

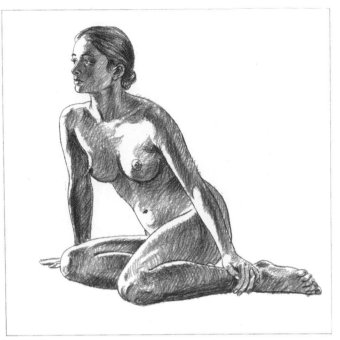

Side Lighting. In this example of extreme side lighting, the light comes from the left and slightly behind the figure. Only the left edges of the forms catch the light. Everything else is in shadow. Protruding forms such as the forehead, breast, and abdomen catch a bit more light.

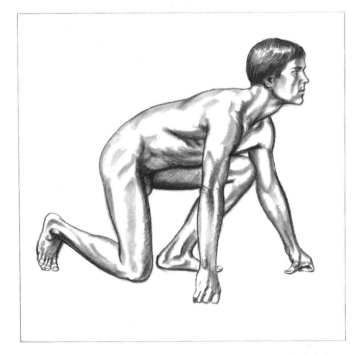

Frontal Lighting. This is the most delicate kind of lighting—as if the light source were directly in front of you, hitting each form of the model's body right in the center. Thus, the center of the form catches the light and the sides curve away into shadow. Slender strips of shadow appear around the edges of the forms.

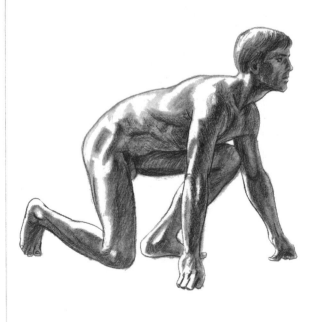

Rim Lighting. The most dramatic lighting is rim lighting—often called back lighting. The light is behind the model. The figure is a dark silhouette with a bit of light creeping around the edges (or the rims) of the forms. As you can see, a change in the light source can transform the same figure into a totally new drawing problem.